IMAGES
of America

RICHMOND
LANDMARKS

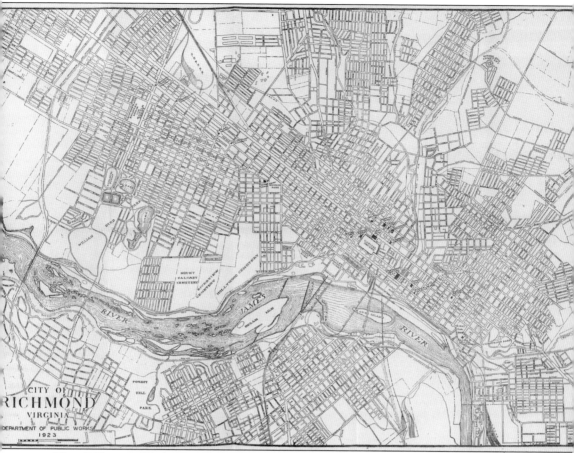

This 1925 map of Richmond shows the city center perched above the James River and the many historic neighborhoods still recognizable by landmarks and street names. (Courtesy of the Library of Virginia.)

IMAGES
of America

RICHMOND
LANDMARKS

Katarina M. Spears

ARCADIA
PUBLISHING

Copyright © 2012 by Katarina M. Spears
ISBN 978-0-7385-9762-1

Published by Arcadia Publishing
Charleston, South Carolina

Printed in the United States of America

Library of Congress Control Number: 2012938990

For all general information, please contact Arcadia Publishing:
Telephone 843-853-2070
Fax 843-853-0044
E-mail sales@arcadiapublishing.com
For customer service and orders:
Toll-Free 1-888-313-2665

Visit us on the Internet at www.arcadiapublishing.com

For Laura—I could not have paid a better person to be my friend

CONTENTS

Acknowledgments 6

Introduction 7

1. Architecture and Cultural Sites 9

2. Monuments and Memorials 33

3. Sacred Spaces 43

4. The Living City 57

5. Seat of Government 83

6. The Greater Richmond Region 111

ACKNOWLEDGMENTS

My deepest thanks go to my colleagues, who helped me gather images and prepare them for publication: Paige Buchbinder, Mark Fagerburg, Audrey Johnson, Dale Neighbors, Dana Puga, Bruce Rodgers, and Ben Steck. The Library of Virginia boasts some of the most knowledgeable and passionate collections managers, historians, and artists I have known in my many years in the museum field. Thanks also go to Jon Kukla for his review of this work for accuracy, though even as I type this acknowledgment, he has no idea he has already agreed to help.

This and all other photographs in the book are provided courtesy of the Library of Virginia, which maintains a collection of more than 3,000 prints and glass-plate negatives by Harry C. Mann and a total of more than 250,000 photographs and images documenting the history of Virginia and its people. The library was created by the general assembly in 1823 to organize, care for, and manage the state's growing collection of books and official records, many of which date back to the early Colonial period.

The library houses the most comprehensive collection of materials on Virginia government, history, and culture available anywhere. The collections illustrate the rich and varied past of the commonwealth, documenting the lives of Virginians whose deeds are known to all as well as those of ordinary citizens whose accomplishments laid the foundation of our heritage. The library's print, manuscript, map, and photographic collections attract researchers from across the country and the world, while the library's websites provide collection-based content and access to our digital collections to those who are not able to travel to Richmond.

In addition to managing and preserving its collections, the library supplies research and reference assistance to state officials; provides consulting services to state and local government agencies and to Virginia's public libraries; administers numerous federal, state, and local grant programs; publishes award-winning books on Virginia history; provides educational programs and resources on Virginia history and culture for students and teachers; and offers the public a wide array of exhibitions, lectures, book signings, and other programs.

The purchase of this book supports the ongoing mission of preservation, conservation, and access at the Library of Virginia.

INTRODUCTION

The area that would become the city of Richmond was first explored by European colonists led by Capt. John Smith in 1607. Geographically, Richmond is located at the fall line of the James River, the point where the river becomes too shallow to be navigated by oceangoing vessels, making it a natural center of trade in the centuries before railroads offered a cheaper way to ship goods.

In 1785, George Washington did the initial survey work to facilitate the construction of the James River and Kanawha Canal. The canal was designed to tie the port of Richmond, accessible to oceangoing ships, to the western reaches of the state of Virginia, which at that time included what is now West Virginia, Kentucky, and parts of Ohio. As a farmer and merchant, Washington was preoccupied by the elusive dream of a waterway that would carry the rich natural resources and production crops from the western reaches of the fledgling United States to the Atlantic and on to lucrative trade with Europe. The James River and Kanawha Canal never did reach the productivity and usefulness that the merchants and manufacturers of early Richmond had hoped. Flooding and other natural forces made the maintenance of the canal an expensive prospect, and it was eventually abandoned and largely dismantled to accommodate the growing railway system.

Despite the shortcomings of the canal system, Richmond was still in a perfect location to facilitate commerce and trade. Until the 20th century, Richmond was central to the export trade of tobacco and wheat, with the southern end of the city bustling with warehouses and markets. Other Richmond industries included an important iron foundry, Tredegar Iron Works, which provided the raw materials needed during the Civil War. And, not to be forgotten, Richmond was central to the domestic slave trade in the 19th century, after the import of slaves from Africa had been outlawed.

The Second Virginia Convention, at which Patrick Henry delivered his rousing "Give Me Liberty or Give Me Death" speech, took place in Richmond in March 1775. It was one of the pivotal events leading to the American Revolution. Though they did not know it at the time, Patrick Henry and the other delegates who attended the convention, such as Thomas Jefferson and George Washington, were laying the groundwork for the founding of the independent United States. Their call for liberty echoed throughout the colonies and had the unintended consequence of inspiring people from all levels of society to view the American Revolution as an avenue to escape from the injustices of the rigid class system imposed by English society.

Richmond became the capital of Virginia after the American Revolution, when the focus shifted from the colonial capital of Williamsburg and the royal governor appointed by the crown. The Virginia General Assembly convened in Richmond in 1780 and, until the construction of the Virginia State Capitol was complete in 1788, met in a building that no longer exists at Fourteenth and Cary Streets. The Virginia State Capitol was designed by Thomas Jefferson and has undergone two major expansions since then.

The Virginia General Assembly is the oldest legislature that has remained in continuous operation in the western hemisphere. Today, the general assembly convenes every January for

session in Richmond—in odd-numbered years for 30 days and in even-numbered years for 60 days—during which time the downtown area bustles with activity as lobbyists and activists swarm the city to meet with the delegates and senators who serve the 140 constituent districts throughout the commonwealth.

The identity most often associated with Richmond by visitors and outsiders is that of capital of the Confederacy, the seat of government of the failed Confederate States of America (CSA). The CSA had only one elected president, Jefferson Davis, who lived in the White House of the Confederacy—now operated as a museum—on Clay Street; attended church at St. Paul's Episcopal Church, on Franklin Street adjacent to Capitol Square; and was formally inaugurated on Capitol Square in 1862. Monument Avenue, the collection of colossal commemorative statues that march along the divided avenue amidst some of the most posh addresses in Richmond, features, almost exclusively, tributes to the generals who gave their fortunes and lives to the Confederate cause.

Richmond has an incredibly rich history for reasons too numerous to list here. Thanks to organizations such as the Historic Richmond Foundation, Preservation Virginia (formerly APVA), and the Virginia State Department of Historic Resources, many of the buildings, monuments, and landscapes associated with historic events and people have been preserved for the enjoyment and education of future generations. Though many important landmarks have been lost to time, those that are preserved are a lasting testament to the work and lives of Virginians past and present.

This book is by no means an exhaustive study of the important landmarks that make Richmond the quintessential historic American city. I have focused my attention largely on the sites best represented in the prints and photographs collection of the Library of Virginia. Other publications, especially those by the Historic Richmond Foundation, provide a complete exploration of the architecture that defines the unique character of Richmond. The Library of Virginia has also published important, comprehensive works about some of the landmarks discussed here, particularly the Virginia State Capitol, the Executive Mansion, and Hollywood Cemetery.

One

ARCHITECTURE AND CULTURAL SITES

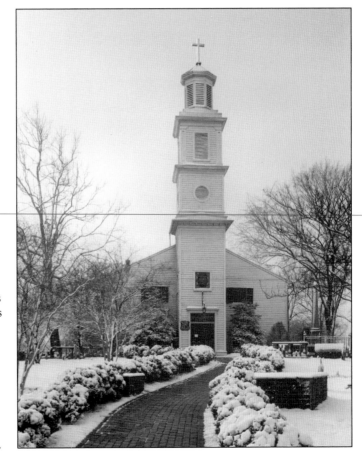

The original wooden St. John's Church was a modest rectangular structure erected in 1741. The surrounding burial ground, shown here after a light snow in 1957, includes the graves of several famous Virginians, including George Wythe. The portion of the cemetery that borders Broad Street was the first public burial ground in Richmond and includes the grave of Elizabeth Arnold Poe, the mother of Edgar Allan Poe.

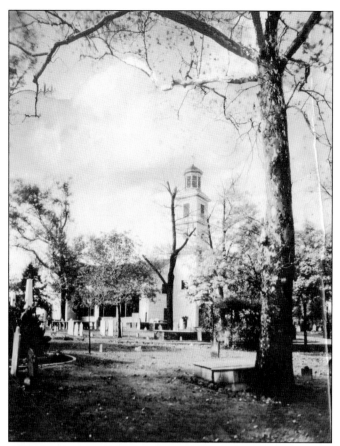

The Second Virginia Convention, the meeting of Virginia's delegates at which Patrick Henry delivered his "Give Me Liberty or Give Me Death" speech, was held in St. John's Church (left) in March 1775. At the time, the church was the only building in Richmond large enough to accommodate all 100 delegates, who included Thomas Jefferson, George Washington, and Peyton Randolph.

Though not officially dated, the photograph of St. John's Church below shows a class trip to the landmark shrine to liberty after the steeple was blown down in a storm in 1863 and before it was reconstructed in 1866.

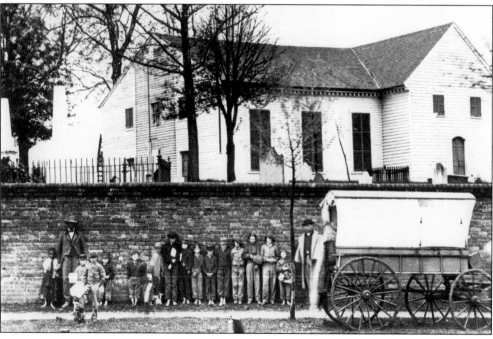

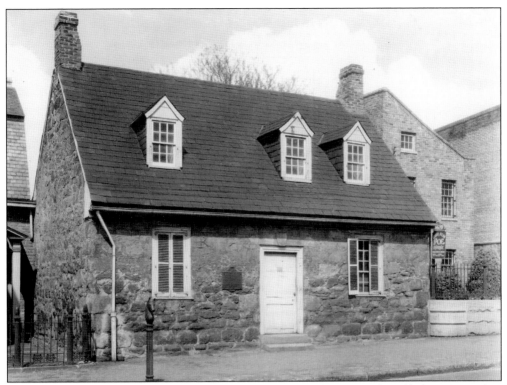

Though it has no direct relation to Poe's life and work, since the 1920s, the Old Stone House has been the most recognizable structure of the Poe Museum. All of the buildings where Poe lived or worked during his many years in Richmond have long since been demolished. The Poe Museum holds one of the most important collections relating to Poe's life and work in the world.

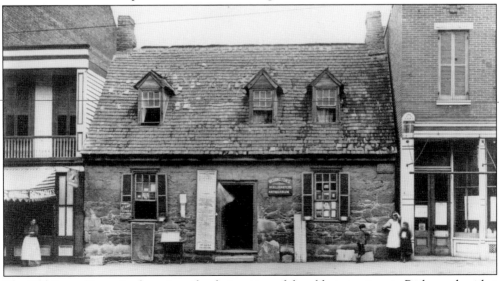

The Old Stone House is often given the designation of the oldest structure in Richmond, with a construction date—based on official records as opposed to physical dating techniques—of 1737. At one time, local legend claimed that the site was used as "Washington's Headquarters" during the American Revolution, but there is no evidence that Washington ever actually visited the site.

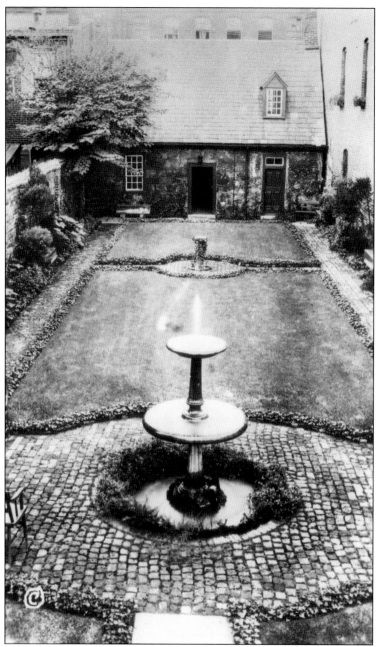

The Enchanted Garden, behind the Old Stone House, was designed to interpret elements of Poe's poems and short stories. The Poe shrine that anchors the garden was constructed from brick, stone, and wood salvaged from the Southern Literary Messenger building, which was once located at Fifteenth and Main Streets. Poe held his first professional writing job at the Southern Literary Messenger, but the building was demolished during World War I. After the war, the salvaged materials were relocated to the Poe Museum at Twentieth and Main Streets. Two of the main elements, the fountain and the shrine of the Enchanted Garden, can be found in Poe's poem "To One in Paradise:" "A green isle in the sea, love / A fountain and a shrine / All wreathed with fairy fruits and flowers / And all the flowers were mine."

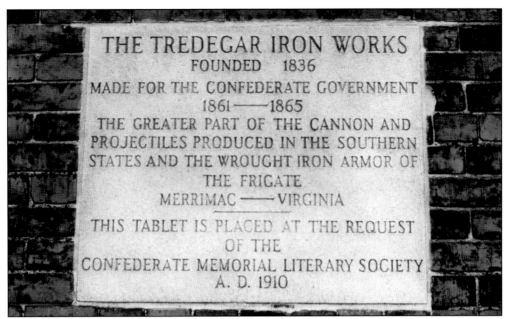

THE TREDEGAR IRON WORKS
FOUNDED 1836
MADE FOR THE CONFEDERATE GOVERNMENT
1861———1865
THE GREATER PART OF THE CANNON AND
PROJECTILES PRODUCED IN THE SOUTHERN
STATES AND THE WROUGHT IRON ARMOR OF
THE FRIGATE
MERRIMAC ——— VIRGINIA

THIS TABLET IS PLACED AT THE REQUEST
OF THE
CONFEDERATE MEMORIAL LITERARY SOCIETY
A. D. 1910

Tredegar Iron Works was founded in 1836, and by 1861, at the start of the Civil War, it was the largest iron foundry in the southern United States. Tredegar played a significant role during the war, creating munitions as well as the iron plating for the first Confederate ironclad ship, the CSS *Virginia*.

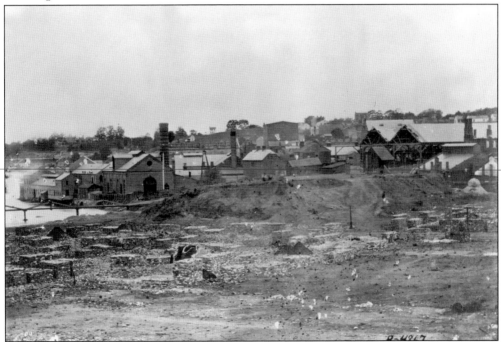

This Matthew Brady photograph of Tredegar Iron Works dates to 1865, shortly after Richmond fell to Union forces. Most of the tobacco warehouses and other industries along the James River were burned by the fleeing Confederates once the city fell. Though Tredegar would be rebuilt after the war, it would never again reach the level of production it had before or during the war.

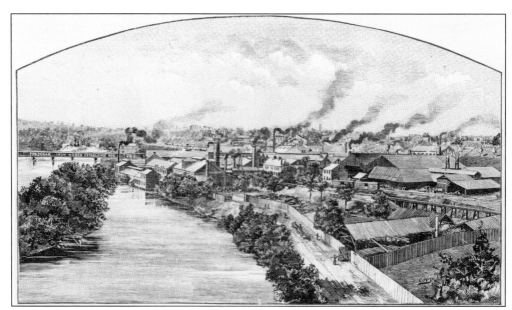

This illustration of Tredegar Iron Works was published in *Richmond, Virginia and the New South* in 1889. The historic structure is now the site of the National Park Service visitor center for the Richmond National Battlefield Park as well as the American Civil War Center, a private nonprofit museum.

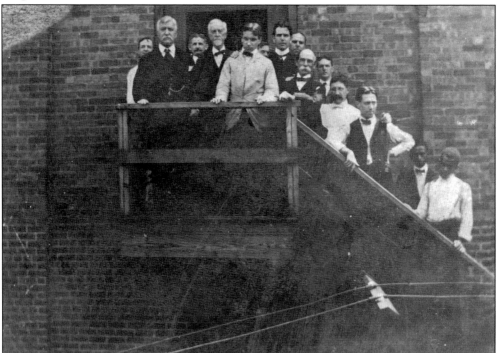

This undated group photograph is part of the Tredegar Iron Works company records from the latter half of the 19th century. The people in the image are presumably company employees. The collection of the Library of Virginia includes many business record archives, as they are important tools for historical research.

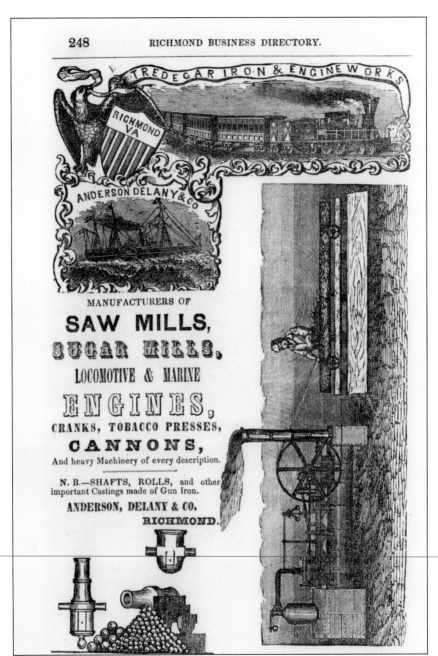

This print advertisement for Tredegar Iron Works is from the *North Carolina and Virginia Gazetteer and Directory* in 1856. In the early months of the Civil War, when the Confederate government was desperate to build its supply of weapons and ordnance, Tredegar employed about 900 men, 540 of whom worked exclusively in the production of ordnance. Company records from January 1862 indicate that there were 131 slaves working in the foundry, many of them as skilled laborers. Slave labor was relied on heavily by Tredegar in the decades leading up to the Civil War. Slaves usually worked a 10-hour day and had a set of tasks that had to be completed during their shift. Once his obligation to the factory was complete, a slave could elect to work extra hours and be paid a wage. Some slaves were owned by the company, while others were rented from other owners.

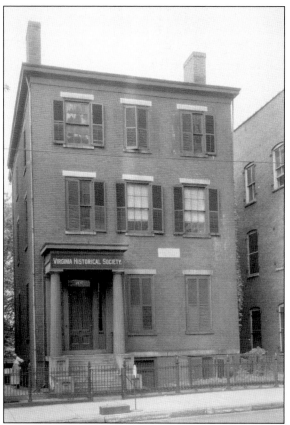

The Virginia Historical Society (VHS) was founded in Richmond in 1831, and John Marshall, the fourth chief justice of the Supreme Court, served as its first president. The VHS had no fixed address until 1893, when it adopted this building, 707 East Franklin Street, which had been the wartime residence of Gen. Robert E. Lee's family.

In 1946, the Virginia Historical Society moved into its permanent home, known as Battle Abbey, on Boulevard just below Monument Avenue. Battle Abbey (below) was first constructed as the repository for the Confederate Memorial Association, and architectural elements within the structure reflect the building's original purpose. These elements include bas-relief seals of the 11 Confederate states and *The Four Seasons of the Confederacy*, a series of heroic murals by French artist Charles Hoffbauer.

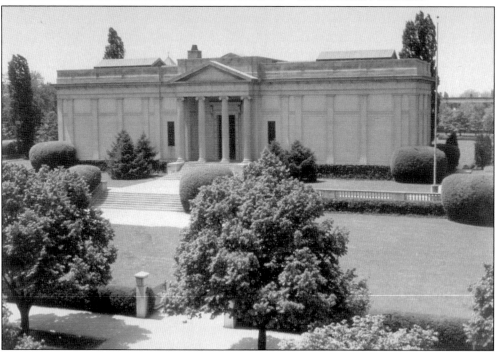

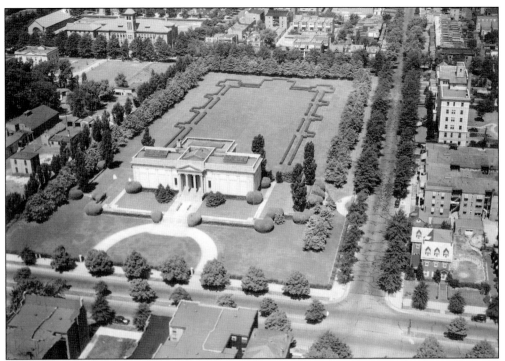

This aerial view of Battle Abbey reveals the grand scale of the architecture. At the top left of the photograph is the Pauley Center, which is now part of the Virginia Museum of Fine Arts campus. The 19th-century structure was originally the Home for Needy Confederate Women. The home was established by the state legislature in 1898 so widows and other dependents of Confederate veterans could turn over their complete estates in exchange for lifelong care.

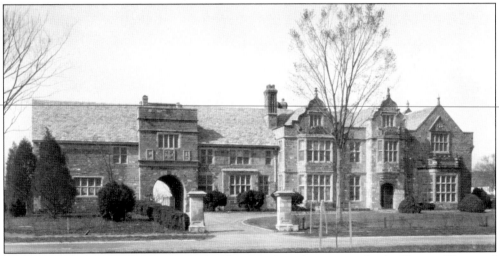

The Virginia House has been preserved and operated as a historic site by the Virginia Historical Society since the sudden deaths of its original owners, Alexander Weddell, the US ambassador to Spain and Argentina, and his wife, Virginia, in 1948. The house was constructed over a period of several years from the architectural salvage of a 12th-century priory in England and two other historic English buildings. The grand manors of England's landed gentry inspired the overall design of the house.

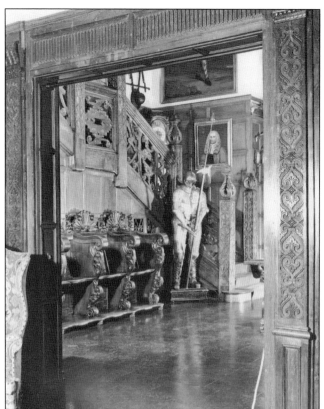

This interior view of the Virginia House reveals the Weddells' wealth and taste for important art and antiques. In addition to his work as a US ambassador, Alexander Weddell served as a diplomat in the US government for 20 years, working at posts in Sicily, Athens, Beirut, Cairo, and Calcutta.

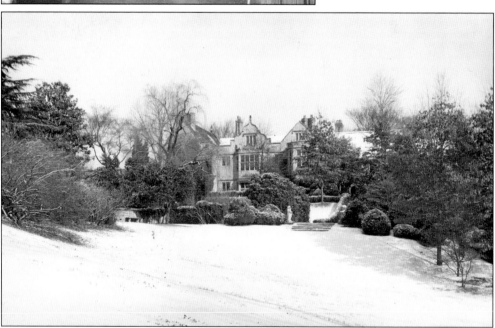

The Virginia House is located in the posh Windsor Farms neighborhood of Richmond. Built in the 1920s, the grand home incorporates salvaged materials from three historic English buildings. Windsor Farms was one of Richmond's first planned neighborhoods, designed in the mid-1920s.

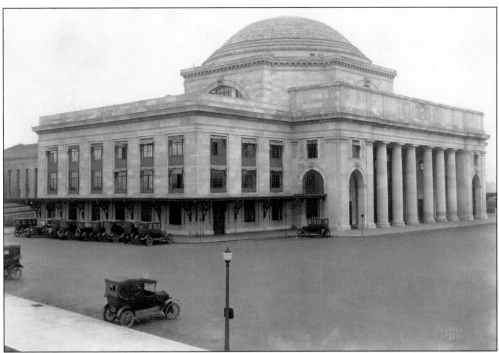

Designed by architect John Russell Pope in 1917 and completed in 1919, Broad Street Station (above, also known as Union Station) served as the southern terminus for the Richmond, Fredericksburg & Potomac Railroad and functioned as a train station until 1975. The Science Museum of Virginia took over the space in 1976 and a year later opened their first exhibit gallery in the new location.

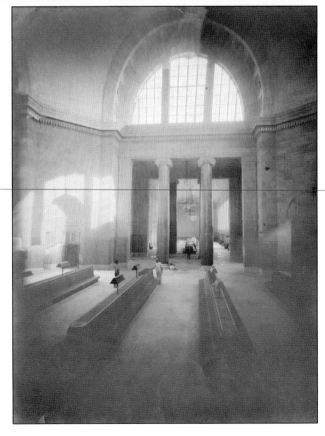

This interior view of Union Station shows what is now the main lobby of the Science Museum of Virginia. The museum was created by the Virginia General Assembly in 1970, although its origins can be traced back to the collection established for exhibition at the 1907 Jamestown Exposition.

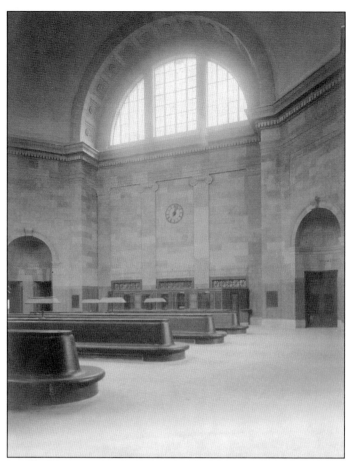

The main lobby of the Science Museum of Virginia now houses a massive pendulum, a gift shop, and a café and is a popular space for special events. The building was preserved through adaptive reuse, though the interior was extensively remodeled. The museum now includes an IMAX theater and three floors of permanent and temporary exhibits.

The aerial photograph of Broad Street Station below was taken in 1920, when rail transportation was still a vital part of Richmond's economy. Today, the area around Broad Street Station is a busy commercial district with the Children's Museum of Richmond next door.

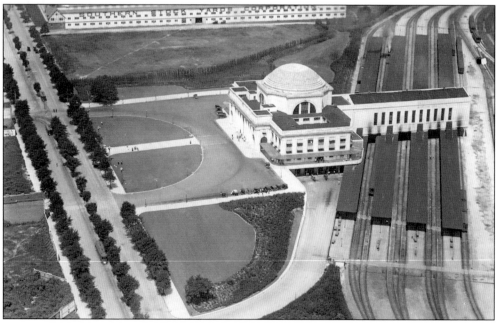

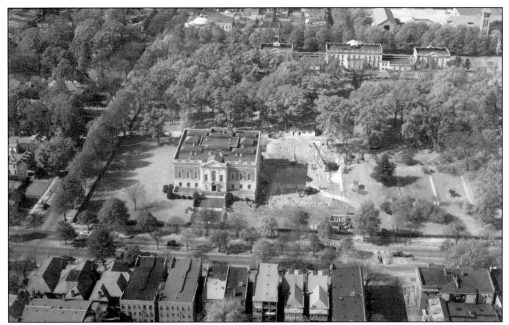

The Virginia Museum of Fine Arts (VMFA) is a state-owned art institution that also relies on private support to take care of its art collection, one of the largest and most significant collections in the country. The VMFA has gone through several expansions since opening its first permanent gallery space in this English Renaissance-style building on Boulevard, which is the anchor for Richmond's museum district.

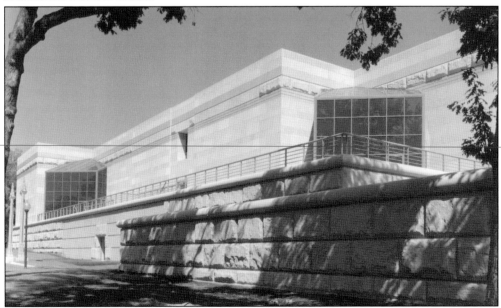

The 90,000-square-foot west wing of the Virginia Museum of Fine Arts was opened in 1985. A large portion of the funding, as well as the art collections exhibited within, were donated by the Lewis family, the founders of the Best Products company, which was once headquartered in Richmond. The Best Products chain has since gone out of business, but its legacy lives on in the Lewis Gallery and the Best Café.

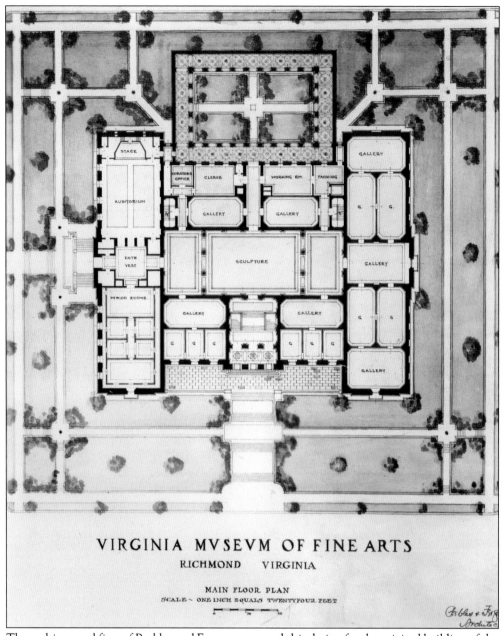

VIRGINIA MVSEVM OF FINE ARTS

RICHMOND VIRGINIA

MAIN FLOOR PLAN
SCALE ~ ONE INCH EQUALS TWENTYFOUR FEET

The architectural firm of Peebles and Ferguson created this design for the original building of the Virginia Museum of Fine Arts (VMFA). The original design included two side wings that were not built, though the VMFA has gone through several expansions since it opened in 1936. The museum campus now occupies more than 13 acres. The VMFA is operated by the Commonwealth of Virginia but was founded through the generosity of many private donors, who donated their personal art collections as well as funding. Judge John Barton Payne was the first donor to contribute his personal art collection, about 50 paintings, and later pledged the seed funds to finance the original building. The most recent expansion of the VMFA was funded through a generous gift from James W. and Frances G. McGlothlin.

From 1885 to 1941, the VMFA campus was the site of Camp No. 1, a home for poor and infirm Confederate veterans. In this image, the building to the left is known as the Robinson House and was constructed just prior to the Civil War. It served as the administration building and museum for the Confederate veterans' home and hospital. Just beyond the parade ground is the hospital building for the camp, which no longer exists.

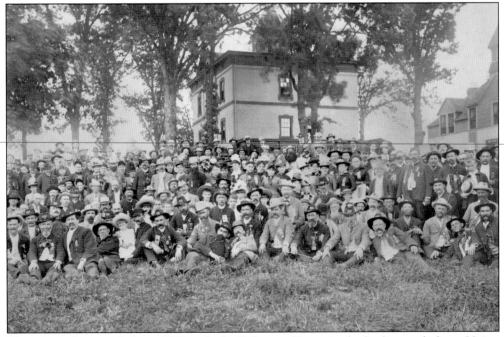

This group photograph from 1887, with the Robinson House in the background, shows Union veterans from the Gen. Frederick W. Lander Post No. 5, Grand Army of the Republic, on a visit to Camp No. 1.

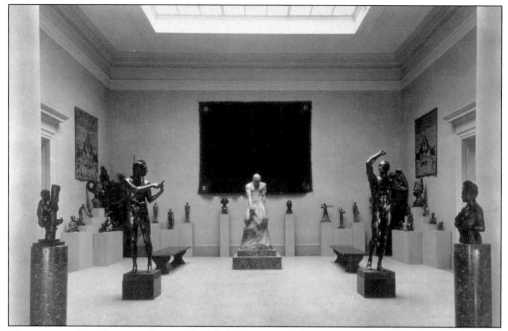

This image of a sculpture gallery at the VMFA was part of a large photograph collection featured at the 1939 New York World's Fair highlighting Virginia's history, industry, and culture. The "Virginia Room" at the New York World's Fair was designed by Leslie Cheek Jr., the director of the VMFA from 1948 to 1968.

The Lewis Galleries of contemporary art are part of the west wing addition of the VMFA. The west wing was the last major expansion until 2010, when the museum's largest and most ambitious expansion was completed. After two years of construction, the VMFA reopened to an eager public, with galleries, restaurants, a sculpture garden, a library, a theater, and much more now covering more than 13 acres.

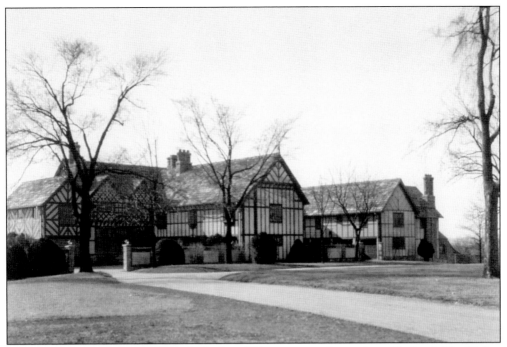

Agecroft Hall was originally built in the late 15th century in Lancashire, England. The Tudor-style estate fell into disrepair by the late 1800s, and in 1925, it was sold to Thomas C. Williams Jr. of Richmond. Williams had the house dismantled, crated, shipped, and reconstructed in the Windsor Farms neighborhood overlooking the James River. Agecroft Hall is now operated as a museum and features a collection of English furnishings representing several centuries.

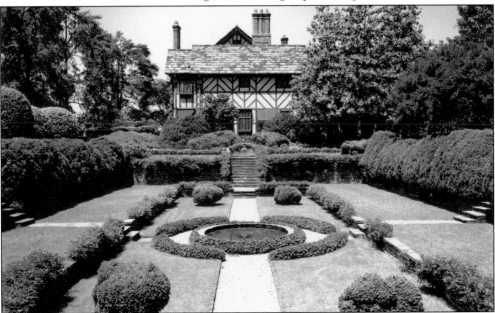

The formal gardens of Agecroft Hall were designed by renowned landscape architect Charles Gillette and feature period-appropriate designs as well as utility plants for medicinal and culinary purposes. Each year, Agecroft Hall hosts outdoor Shakespeare performances on the grounds.

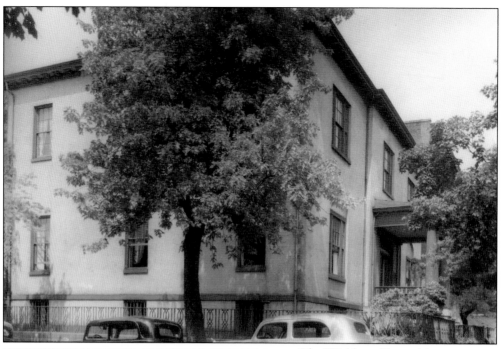

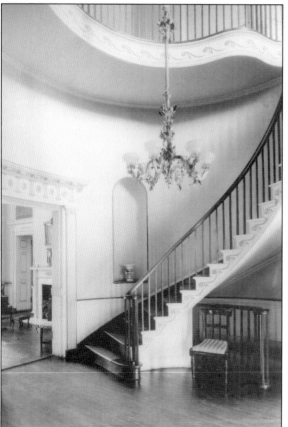

The Wickham House (above, built in 1812) became the home of the Valentine Museum in 1898. The museum was named in honor of Mann S. Valentine Jr., whose personal wealth, home, and art collections comprised the foundation of the museum's collections. Today, the Valentine Richmond History Center interprets the history and culture of Richmond and has expanded several times in its century of operation.

The "floating" grand staircase and detailed millwork in the Wickham House are just two of the important architectural details of the 1812 Neoclassical property. The Wickham House is now operated exclusively as a historic house museum, with regular museum operations taking place in an adjacent building at 1015 East Clay Street.

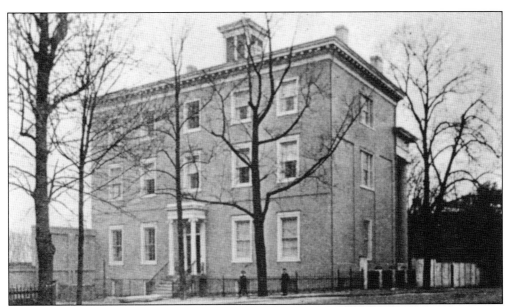

In Richmond's Court End district (once called Shockoe Hill) stands the 1818 structure that served as the White House of the Confederacy, where Jefferson Davis and his family lived for most of the Civil War. The photograph above dates to 1896, the same year the house opened as the Museum of the Confederacy. Today, the museum is in an adjacent building and houses significant artifacts and archival collections related to the Confederacy.

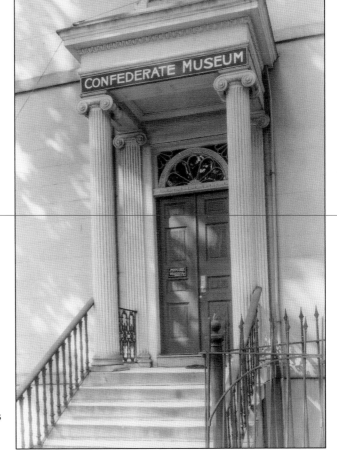

This is the entrance of the White House of the Confederacy at 1201 East Clay Street. The house, originally built for John Brockenbrough in 1818, was in the same neighborhood as the residences of other well-to-do Richmonders such as Chief Justice John Marshall and John Wickham.

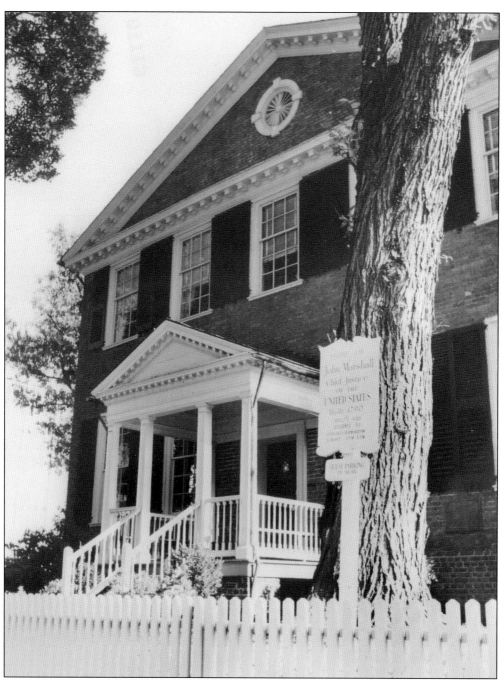

The home of Chief Justice John Marshall has been owned and operated as a museum by Preservation Virginia (formerly Association for the Preservation of Virginia Antiquities, or APVA) since 1913. John Marshall and his family lived in the house from 1790 until his death in 1835, and it remained in the Marshall family until 1911. Marshall served in all three branches of the fledgling US government but is best known for his role as chief justice of the US Supreme Court. The house is in Court End, a fashionable and affluent 19th-century neighborhood just two blocks from Capitol Square.

This document is the Mutual Assurance Society insurance revaluation for the John Marshall house and its associated outbuildings at 818 East Marshall Street, dated October 17, 1815. The Mutual Assurance Society Against Fire on Buildings in the State of Virginia was established by the Virginia General Assembly in 1794. Insurance policies were guaranteed against all losses and damages from fire. Revaluations such as this were required every seven years or whenever any additions were made to a policy, making them an excellent tool for historians to discover what buildings and outbuildings existed on a particular piece of property. The Library of Virginia houses the complete archival record of the Mutual Assurance Society of Virginia. John Marshall, Thomas Jefferson, James Monroe, and Bushrod Washington (the nephew and heir to George Washington) were some of the first customers to hold insurance policies with the company.

The Maggie Walker House (above) is preserved as a museum by the National Park Service and tells the important story of African American history in Richmond in the post–Civil War era. The house, at 110 ½ East Leigh Street, was built in 1883.

Maggie Lena Walker was born in 1864 and grew up in Richmond in the period immediately following the Civil War. In 1903, she became the first African American woman in the United States to found a bank, the St. Luke Penny Savings Bank, and was an important leader in the civil rights movement.

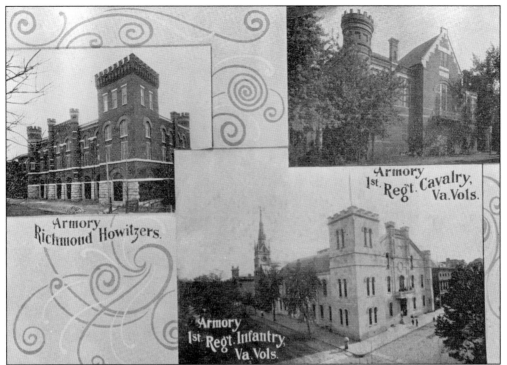

Before the establishment of the National Guard, cities like Richmond maintained volunteer militias that were called on during public emergencies. The volunteer groups used these unique buildings, called armories and designed to resemble castles or ancient fortifications, to store weapons and to run practice drills as well as to use as social clubs for members. These three buildings, all constructed in the 1890s, are no longer standing, but the Richmond Blues Armory and Leigh Street Armories have survived.

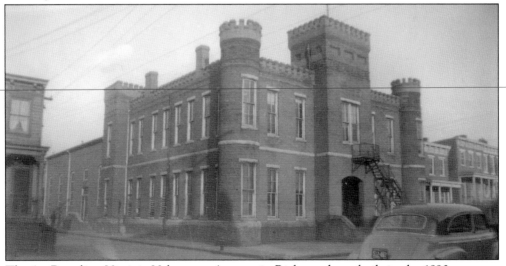

The 1st Battalion Virginia Volunteers Armory in Richmond was built in the 1890s to serve Richmond's first African American regiment. The armory has since served as a school, a community center, and as housing for African American troops during World War II. It is now managed by the Black History Museum and Cultural Center.

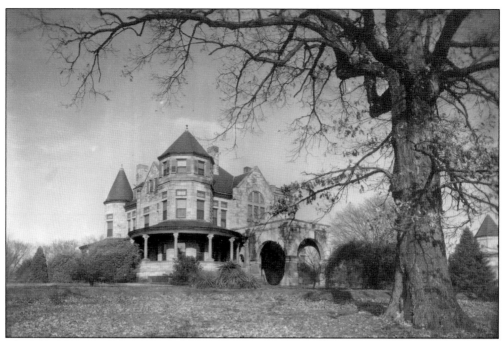

The Maymont estate was acquired in 1886 by James and Sallie Dooley, and by 1893, they had built the 33-room, 12,000-square-foot mansion. Having no heirs, Sallie Dooley bequeathed the house and estate to the City of Richmond for the use and pleasure of its residents. Maymont began operating as a public park and museum only six months after her death.

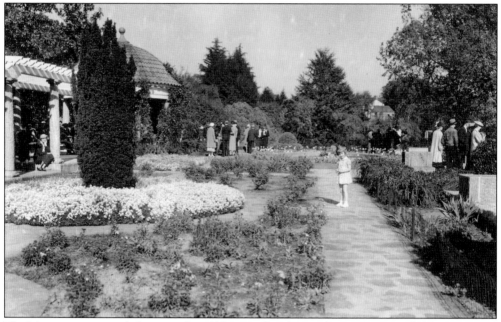

The Maymont estate includes more than 100 acres of gardens and green space, including a Japanese garden, an arboretum, and an Italian garden that date to around 1900 and are still preserved according to the Dooley's designs. The Dooleys donated their vast estate to the city in 1925, stipulating that it was to be used for the pleasure of the people of Richmond.

Two

MONUMENTS
AND MEMORIALS

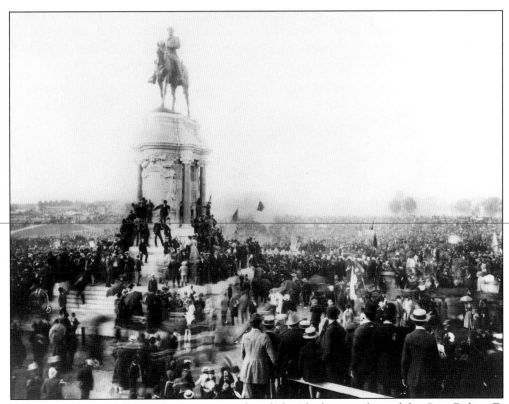

Richmond's famous Monument Avenue was founded with the unveiling of the Gen. Robert E. Lee Monument, where he is seen astride his mount, Traveller, on May 29, 1890. The unveiling took place 20 years after the death of General Lee, the most famous Confederate military leader, who led the Army of Northern Virginia in the war.

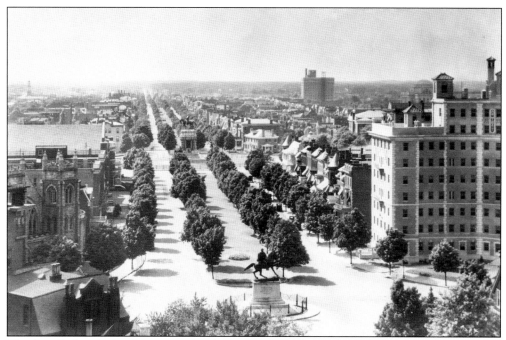

The Gen. Robert E. Lee Monument has become a symbol of Richmond's role as the Confederate capital and a testament to the city's unhealed history. During the first quarter of the 20th century, a posh district of gilded-age mansions was created along Monument Avenue.

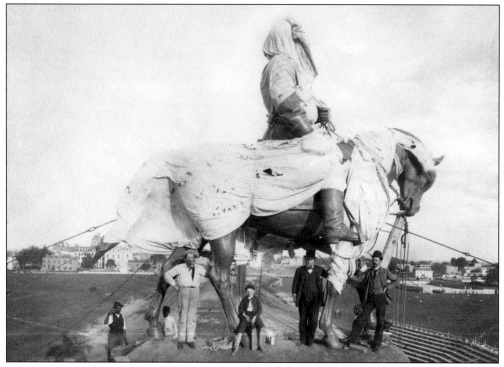

The massive Lee monument, created by French sculptor Marius-Jean-Antonin Mercie, is seen here just after it was hoisted into place for the unveiling in 1890.

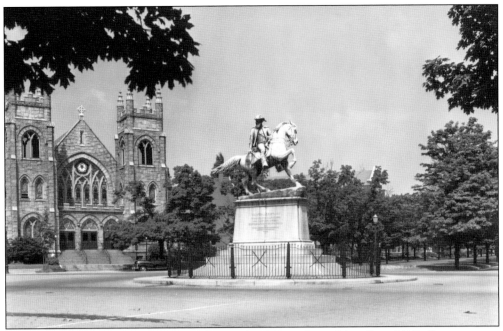

Probably most famous for his role in the Battle of Gettysburg, Maj. Gen. J.E.B. Stuart was an important cavalry leader for the Confederate army. He ultimately gave his life for the cause of the seceded states when he was mortally wounded at the Battle of Yellow Tavern in Henrico, Virginia, just outside Richmond.

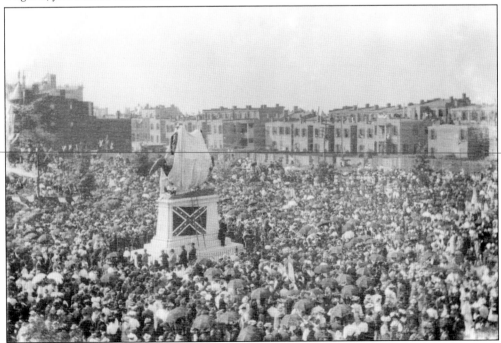

The J.E.B. Stuart monument was erected in 1907 on Lombardy Street and Monument Avenue four years after the first homes were built along Monument Avenue. Stuart was only 31 when he was killed in battle. He is interred at Hollywood Cemetery.

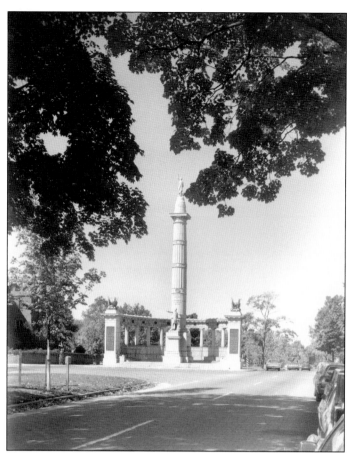

The Jefferson Davis Monument, at Monument and Davis Avenue, was designed by Edward V. Valentine and dedicated in 1907. Davis served as the president of the Confederate States of America from 1861 until the fall of Richmond in 1865.

The 1929 unveiling and dedication of the Matthew Fontaine Maury Monument at Monument and Belmont Avenues drew a large crowd (below). Maury was a Confederate naval officer best known for his scholarly contributions to the study of ocean currents, navigation, and weather patterns at sea.

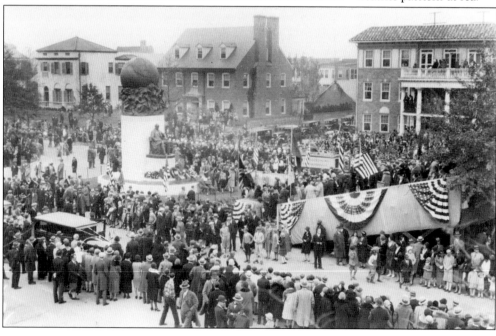

Arthur Robert Ashe Jr. was the first and only African American male to win Wimbledon, the US Open, and the Australian Open. After achieving fame as a tennis player, Ashe devoted his life and celebrity to social causes and is probably best known for his activism against apartheid in South Africa and for raising awareness about HIV/AIDS after contracting the disease from a blood transfusion.

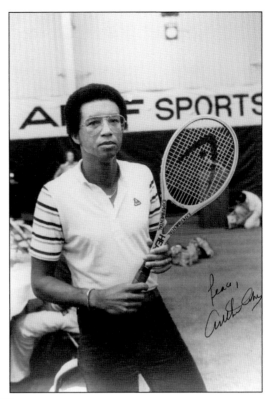

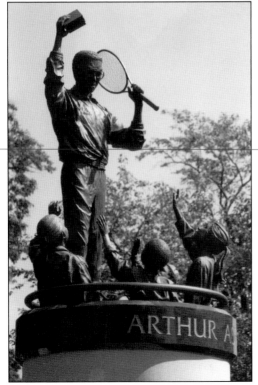

The Arthur Ashe Monument on Monument Avenue was added in 1996. It is the only monument on Monument Avenue that does not honor a leader of the Confederate States of America. Born in 1943, Ashe grew up during the most heated era of the civil rights movement. The addition of his monument to Monument Avenue was a source of tension for some Richmonders at the time of its design and installation.

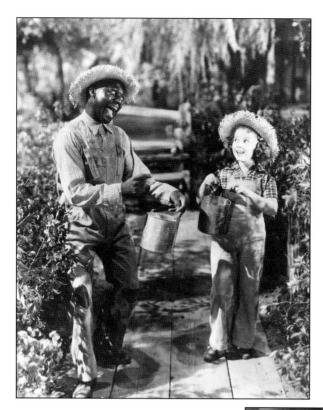

Bill "Bojangles" Robinson was born in Richmond in 1878, and by the time he was a teenager, he had made dancing his life's pursuit. Bojangles was popular with both white and black audiences throughout his life but is perhaps best known for the series of films he starred in with Shirley Temple in the 1930s. This still image is from 1937's *Rebecca of Sunnybrook Farm*. Bojangles died in 1949.

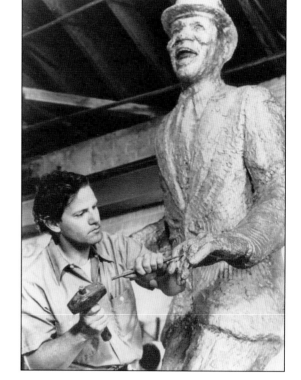

This memorial to Bill "Bojangles" Robinson is in a small park at the intersection of Leigh Street and Chamberlayne Parkway in Richmond. Here, the artist puts the final touches on the cast-aluminum statue.

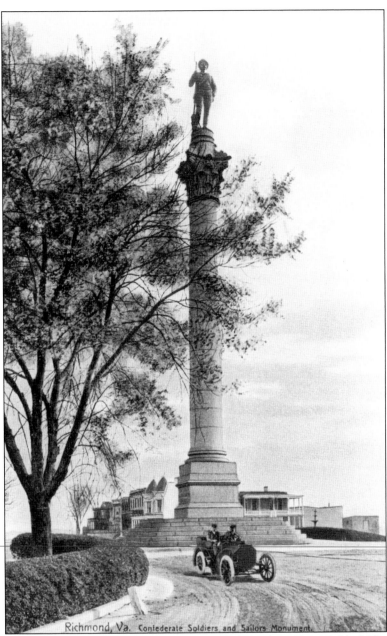

Richmond, Va. Confederate Soldiers and Sailors Monument.

The Confederate Soldiers and Sailors Monument was dedicated in 1894 on Libby Hill at the south end of Twenty-ninth Street in Richmond, overlooking the James River in the historic Church Hill neighborhood. The site boasts some of the best views of the river in the city. The statue atop the 73-foot Corinthian column is meant to memorialize the average Confederate soldier. The monument is about a half-mile from the Chimborazo Hospital (now the Chimborazo Medical Museum), where approximately 75,000 Confederate soldiers received treatment in the three and a half years it operated during the Civil War. Of the hundreds of thousands who died during the Civil War, far more died from disease than from battle. While many medical advancements were made during the Civil War, antiseptic procedures and germ theory were completely unknown at that time.

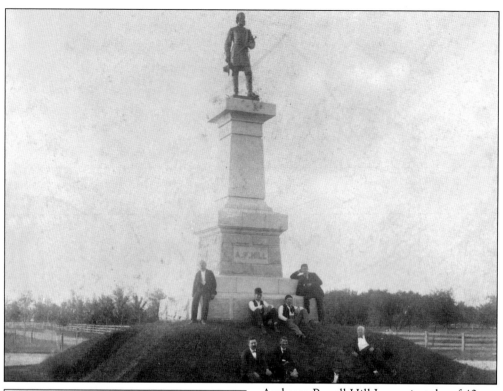

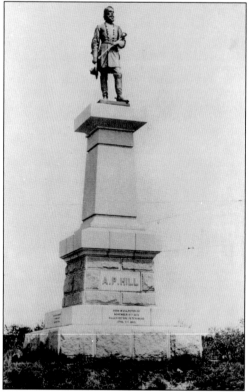

Ambrose Powell Hill Jr. was just shy of 40 years old when he was killed at the Third Battle of Petersburg just one week before General Lee's surrender at Appomattox. A.P. Hill served under Stonewall Jackson until Jackson's death in 1863, at which time he was promoted and served as lieutenant general under Lee. In this image, a group of men, presumably Civil War veterans, pose under A.P. Hill's monument in Richmond.

The A.P. Hill Monument is at the intersection of Hermitage and Laburnum Avenues in northside Richmond. The monument is unusual in that Hill's remains are actually interred underneath. The monument was dedicated on May 30, 1892, on land donated for the purpose by Lewis Ginter. The location was chosen because of its proximity to the site where Hill took command of his first brigade, according to an article in the May 31, 1892, New York Times.

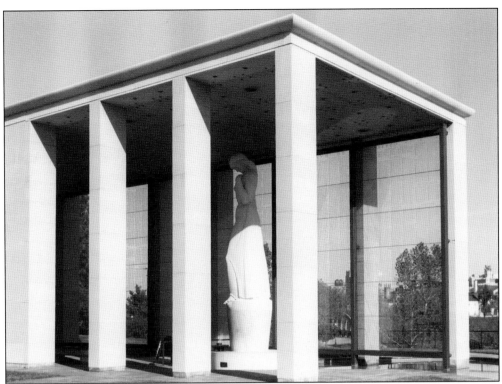

The Virginia War Memorial looms above the James River as a memorial to Virginia's war dead from World War II, the Korean War, the Vietnam War, and the Persian Gulf War. The memorial was first dedicated merely as a shrine, with no staff or programming, in 1956.

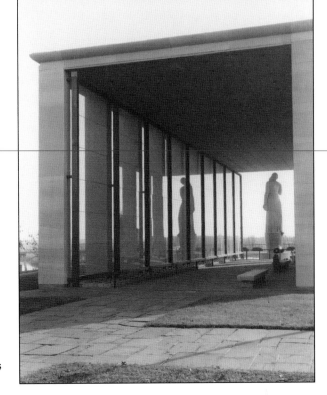

In the 1990s, the Virginia War Memorial expanded with the construction of an 18,000-square-foot visitor center that includes meeting space and exhibits. The memorial now hosts regular events and educational programs.

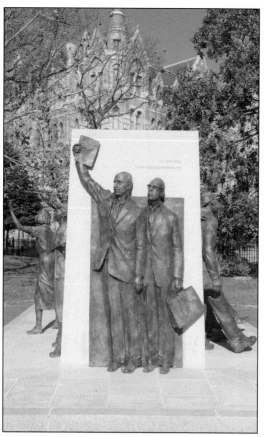

The Civil Rights Memorial was unveiled on Capitol Square in 2008 and portrays seminal events and important members of the civil rights movement in Virginia. At left, Oliver White Hill Sr. and Spottswood W. Robinson III are memorialized. Hill and Robinson were law partners who argued dozens of civil rights cases throughout Virginia in the early 1950s. Their work through the court system was every bit as critical as the more public activist marches and sit-ins. Their legal victories paved the way for equal rights under the law for African Americans.

The monument below honors Barbara Johns, who, in 1951 at the age of 16, initiated a strike against the Prince Edward School Board to demand better conditions for black students. Her actions ultimately led to the lawsuit that would become part of *Brown v. Board of Education*. In 1954, after the Supreme Court overturned racial segregation in public schools, many counties, including Prince Edward, chose to shut down their public school systems.

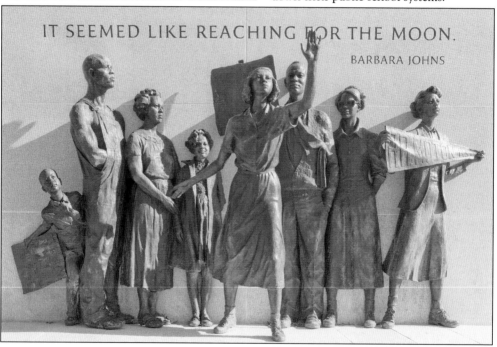

IT SEEMED LIKE REACHING FOR THE MOON.
BARBARA JOHNS

Three

SACRED SPACES

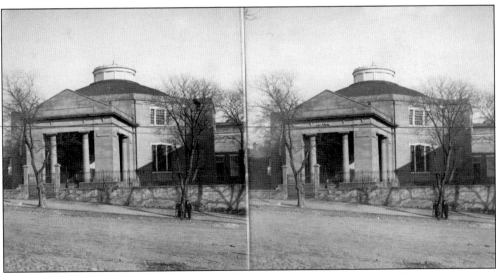

In 1814, Monumental Church was built on the former site of the Richmond Theater, which had burned. Designed by Robert Mills, Thomas Jefferson's only architectural student, the building is a stunning example of Greek Revival architecture. Though it is no longer an active Episcopal church, the original congregation included famous Richmonders such as John Marshall and Edgar Allan Poe. The Historic Richmond Foundation now owns and maintains the building, which is a National Historic Landmark.

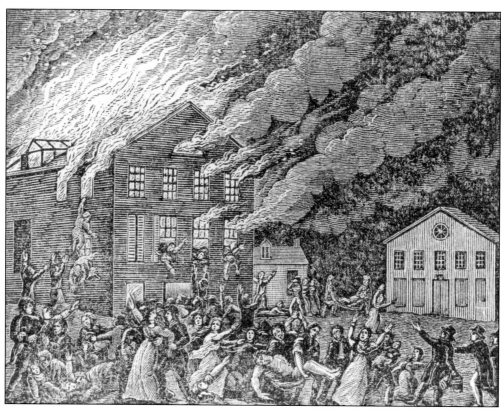

On December 26, 1811, Richmond made national headlines when the local theater burned to the ground and 72 of its most prominent citizens perished in the fire. The victims, burned beyond recognition, were put into a mass crypt encased in brick, which is still in the basement of Monumental Church. The illustration above depicts the theater fire. Most of the victims of the blaze were women, which, at the time, called into question the reputation of the southern gentleman.

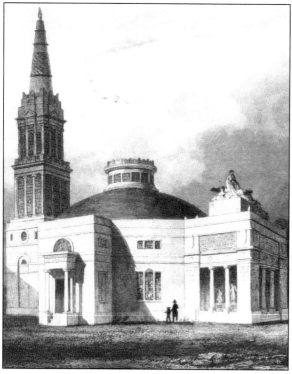

William Goodacre was a landscape artist and painter who completed several views of Virginia landmarks in the 1820s for the publication *History and Topography of the United States*, published in 1831. This conceptual drawing of Monumental Church (left) by Goodacre was made into an etching for publication in Boston.

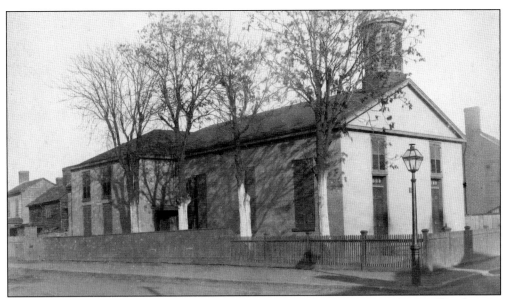

In 1867, the charismatic Rev. John Jasper founded the Sixth Mount Zion Baptist Church in an abandoned Confederate horse shed on Brown's Island, along the James River. Thanks to Reverend Jasper's strong appeal, in just two years the church had outgrown its first home and moved to downtown Richmond. In 1957, the church was saved from demolition during the construction of Interstate 95 and is now a centerpiece of the Jackson Ward historic district.

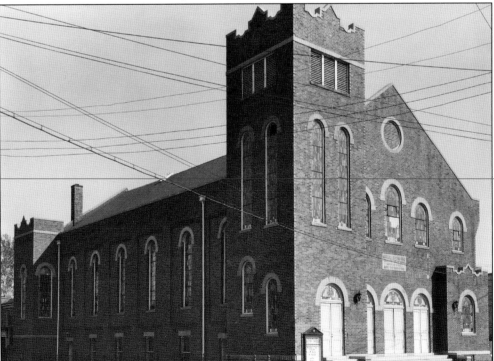

The Sixth Mount Zion Church building has been expanded and remodeled several times in its long history. This photograph was taken in the 1950s and shows the final expansion of the building, which was completed in the 1920s.

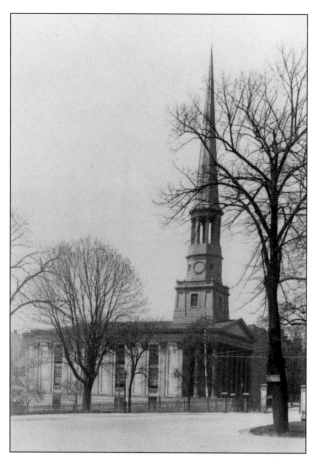

St. Paul's Episcopal Church (left) was built in 1845 just across Ninth Street from Capitol Square. It is seen here with its original steeple, which was replaced in 1900 after a hurricane. The steeple was replaced by a small dome over the belfry, but the tall spire once dominated the Richmond skyline. Many old photographs of Richmond can be dated by the existence or absence of the St. Paul's steeple.

St. Paul's Episcopal Church was an outgrowth of the Monumental Church congregation, which had outgrown its space by 1843. During the Civil War, both Jefferson Davis and Robert E. Lee were members of the St. Paul's congregation. The family pews of Davis and Lee are marked on this image. At the time it was built, St. Paul's was the largest Episcopal church in Virginia, with enough seating to accommodate 1,000 congregants.

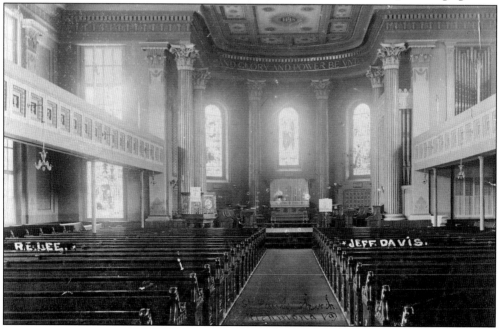

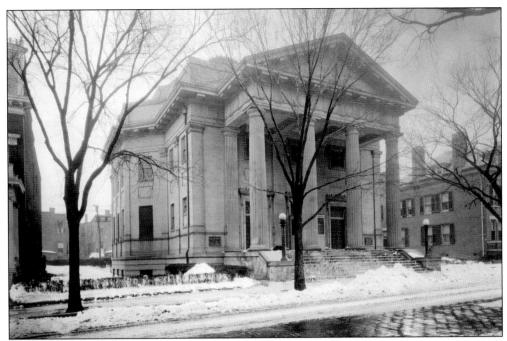

The third synagogue building of the Temple Beth Ahabah (above) was at Franklin and Ryland Streets. The first Beth Ahabah temple, constructed in 1822, was later replaced by a different structure on the same site. In 1904, the third temple was built at its current site. The temple is also home to the Beth Ahabah Museum and Archives, which is open for visitation from Sunday through Thursday.

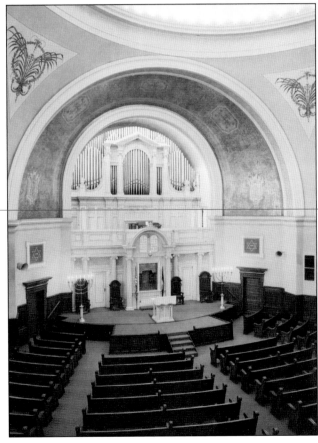

The third Beth Ahabah temple was designed in the Neoclassical style by the same architectural firm that designed the 1906 expansion of the Virginia State Capitol. Beth Ahabah has its roots in the first Jewish congregation established in Richmond, Kahal Kadoshe Beth Shalome, which was founded in 1789, just three years after the Virginia General Assembly enacted the Statute for Religious Freedom.

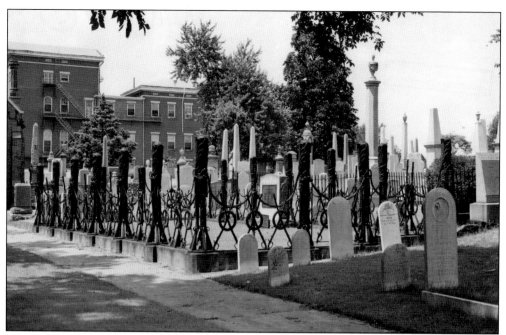

The Hebrew Cemetery is maintained by Beth Ahabah and was established in 1816 to succeed the Franklin Street Burying Grounds. At Fourth and Hospital Streets, the cemetery includes the graves of 30 Jewish Confederate soldiers who died in or near Richmond during the Civil War.

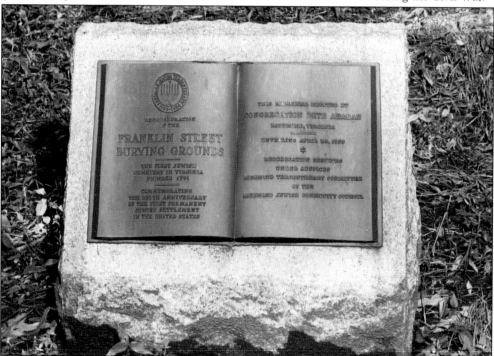

The Franklin Street Burying Grounds in the Shockoe Bottom neighborhood is a small fenced plot with only this marker and a small sign above the gate to indicate its original purpose. Established in 1791, it was the first Jewish burial ground in Virginia.

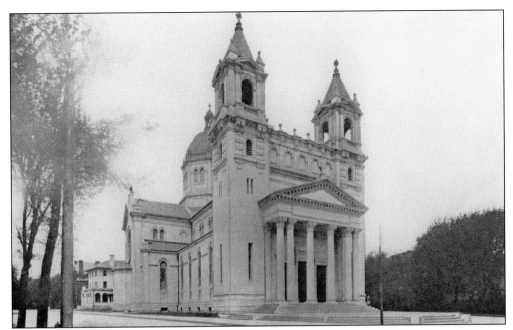

The Cathedral of the Sacred Heart (above), dedicated in 1906, is adjacent to Monroe Park and the Virginia Commonwealth University campus. The Italian Renaissance Revival–style cathedral was designed by Joseph H. McGuire of New York. It is just one of many stunning architectural works in Richmond.

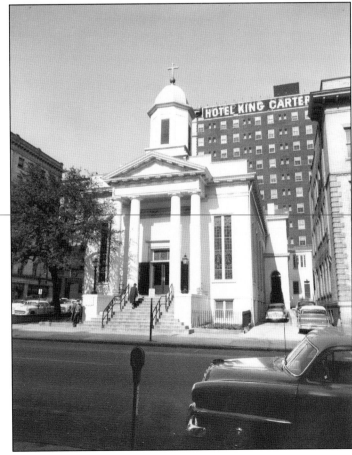

St. Peter's Catholic Church (right), at Eighth and Grace Streets, is the oldest Catholic church in Richmond, dedicated in 1834. John Banister Tabb, an ordained Catholic priest and educator who is perhaps best remembered as a poet, worshipped at the church, which is located one block away from historic St. Paul's Episcopal Church, just one block from Capitol Square.

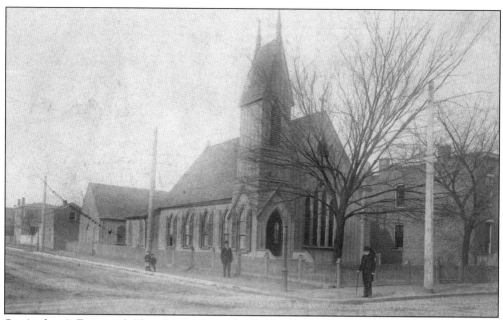

St. Andrew's Episcopal Church grew out of a St. Paul's Church Sunday school effort for the working-class people of Richmond's Oregon Hill neighborhood. The first church building was a modest wooden structure constructed in 1877. Grace Arents provided the funds to expand St. Andrew's into the stone Gothic-style church it is today. In 1894, Arents also founded St. Andrew's School and the first free school to serve the city's working poor.

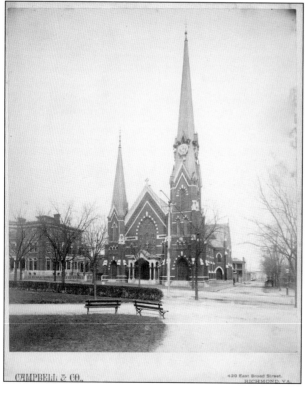

The construction of the first Park Place Methodist Church, seen here, was completed in 1886. In 1921, the church was renamed Pace Memorial Methodist Church to honor the donor who had provided the land and money for the construction of the original church. The original church was destroyed by fire in 1966 and rebuilt in 1969.

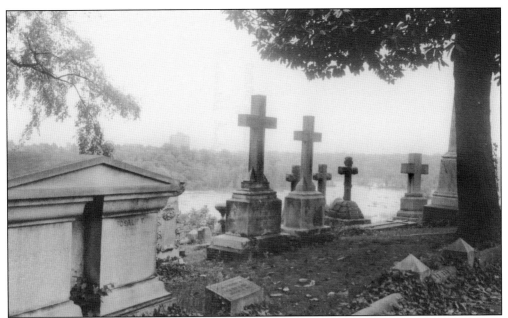

Designed in 1847, Hollywood Cemetery (above) perfectly exemplifies the rural cemetery movement of the mid-19th century, with its rolling lawns, picturesque river views, and Victorian and Neo-Gothic architectural designs. Hollywood Cemetery is the final resting place of US presidents James Monroe and John Tyler, Confederate States president Jefferson Davis, and 25 Confederate generals.

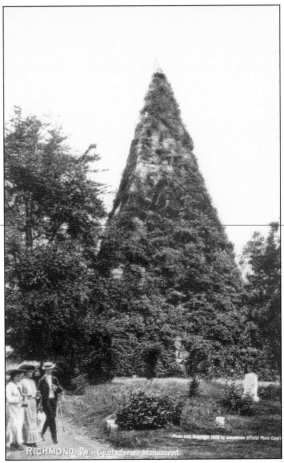

This 90-foot granite pyramid was built in 1869 as a memorial in honor of the 18,000 enlisted Confederate soldiers buried in Hollywood Cemetery, many whose names are unknown. Most of the large hospitals that served the Confederate wounded—such as Chimborazo on the outskirts of Church Hill—were located in Richmond, and most of the soldiers who died in those hospitals are buried at Hollywood Cemetery.

The gravestone of Matthew Fontaine Maury, who is commemorated on Monument Avenue for his Confederate naval service, is the tall stone in the foreground. The gazebo-like structure to the right and rear is the grave of the fifth president, James Monroe, who also served in the elected offices of delegate, governor, and senator for Virginia before and after his presidency.

This drawing of President Monroe's tomb is by German architect Alfred Lybrock, who designed the cast-iron structure that sits over the tomb. Monroe died and was buried in New York in 1831, but in 1858, his remains were relocated to Virginia, his native state. This monument was installed in 1859.

HOLLYWOOD CEMETERY.

THIS BEAUTIFUL AND ATTRACTIVE

CEMETERY

HAS BEEN LAID OFF INTO

Sections and Lots;

Each Lot being Marked and Numbered, and its Size and Price indicated upon the Plan of the Ground.

SELECTIONS OF

BURIAL LOTS

May be made, and the Plan seen, either at the office of MR. WELLINGTON GODDIN, on 11th Street, or at the *CEMETERY*, in the possession of MR. J. O'KEEFFÉ, the Superintendent.

THE LOTS VARY IN PRICE FROM $12 TO $110 EACH.

SINGLE GRAVES

MAY BE OBTAINED FOR $2, OR $3, ACCORDING TO LOCATION.

The Superintendent has a sufficient force to attend to all calls upon the shortest notice.

☞ Proprietors are authorized to IMPROVE THEIR LOTS, *(at their own expense,)* subject to the Rules of the Company. For further information apply to

THOMAS H. ELLIS,
President.
JAMES H. GARDNER,
Treasurer.
OR
WILLIAM H. HAXALL,
Secretary.

This 1852 advertisement for Hollywood Cemetery shows the going price for single graves was $2 to $3, depending on location, and $12 to $110 for full burial lots. By 1872, the price had been raised, with an additional $3 charged per grave dug. Today, rates range from $2,000 to $5,000, depending on location. By 1880, the cemetery also generated revenue by offering perpetual or annual care and maintenance of the graves. Until the 1960s, most of Hollywood Cemetery was maintained by the use of push lawn mowers and hand tools. Even graves were dug by hand until heavy equipment was introduced in the 1960s. Today, more than 80,000 people are buried at Hollywood Cemetery. It is also a popular tourist attraction, with historic walking tours offered and signage to guide interested visitors. A nonprofit foundation was established to fund preservation efforts and to raise awareness about the historical significance of the site.

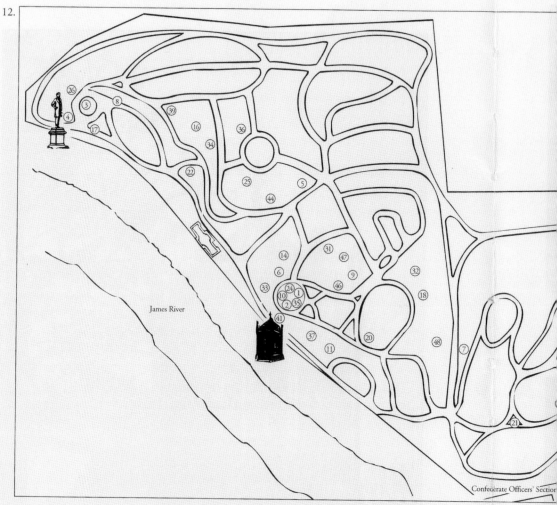

James River

Confederate Officers' Section

PRESIDENTS OF THE UNITED STATES OF AMERICA

| 1. | James Monroe | 1817–1825 |
| 2. | John Tyler | 1841–1845 |

PRESIDENT OF THE CONFEDERATE STATES OF AMERICA

| 3. | Jefferson Davis | 1861–1865 |

GOVERNORS OF VIRGINIA

4.	Fitzhugh Lee	1886–1890
5.	Charles Triplett O'Ferrall	1894–1898
6.	John Garland Pollard	1930–1934
7.	William "Extra Billy" Smith	1846–1849, 1864–1865
8.	Claude Augustus Swanson	1906–1910
9.	Henry Alexander Wise	1856–1860

OTHER NOTABLES

10. Joseph Reid Anderson
11. James J. Archer
12. James Branch Cabell
13. Robert H. Chilton
14. Philip St. George Cocke
15. Raleigh E. Colston
16. John R. Cooke
17. Jabez Lamar Monroe Curry
18. Virginia Randolph Ellett
19. First Confederate Burial
20. First Burial in Hollywood
21. Douglas Southall Freeman
22. Lewis Ginter

ollywood Cemetery

Richmond, Virginia

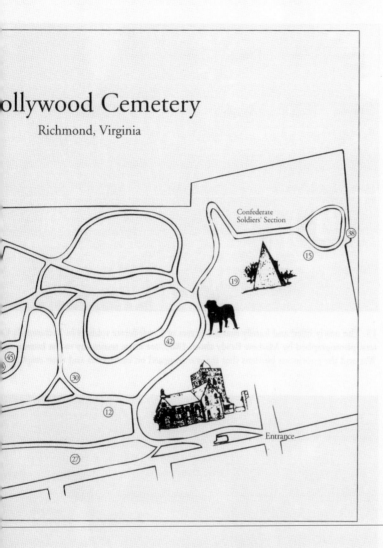

Confederate
Soldiers' Section

Entrance

This map of Hollywood Cemetery details some of the important landmarks within. It was originally published in *Hollywood Cemetery: History of a Southern Shrine*. Note the figure of a dog on the right, which represents the famous cast-iron dog statue that stands watch over the grave of a young girl who died in 1862. Urban legends abound about the dog and why it was created. Other landmarks include the grave of Jefferson Davis, the Confederate Memorial pyramid, and the tombs of US presidents Monroe and Tyler. The Romantic Period in European art helped to inspire the rural cemetery movement, popularizing romantic ideals about art, literature, nature, and even death. At the time it was created, Hollywood Cemetery was on the outskirts of the city, and it has retained strikingly beautiful views of the James River.

Glasgow

n Henry Haxall

Heth

Hunton

). Imboden

d Johnson

R. Jones

l Jones

Family Plot (tree-shaped monuments)

as M. Logan

oung Mason

r Holmes McGuire

ew Fontaine Maury

36. John K. Mitchell
37. John Pegram
38. George Edward Pickett
39. John Randolph of Roanoke
40. John C. C. Sanders
41. James A. Seddon
42. William E. Starke
43. Walter H. Stevens
44. Isaac M. St. John
45. James Ewell Brown Stuart
46. William R. Terry
47. R. Lindsay Walker
48. Alexander W. Weddell

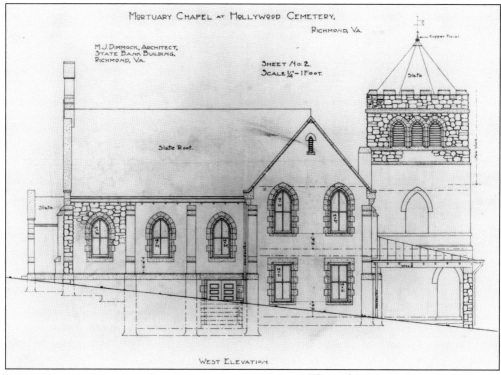

MORTUARY CHAPEL AT HOLLYWOOD CEMETERY.

RICHMOND, VA.

M.J. DIMMOCK, ARCHITECT,
STATE BANK BUILDING,
RICHMOND, VA.

SHEET No. 2.
SCALE ¼" = 1 FOOT.

WEST ELEVATION

The architectural drawing above shows the west elevation of the Mortuary Chapel, near the Cherry Street entrance of Hollywood Cemetery. These plans were drawn in 1897–1898, and the building was completed in 1898. The building now serves as the cemetery office.

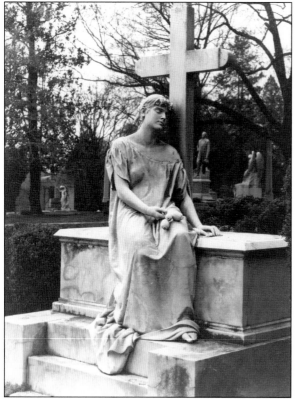

This statue of a mourning woman is another famous landmark in Hollywood Cemetery. The Jefferson Davis grave and statue can be seen in the background, immediately to the right of the large stone cross. Davis was originally buried at a different cemetery but was reinterred at Hollywood in 1893.

Four

THE LIVING CITY

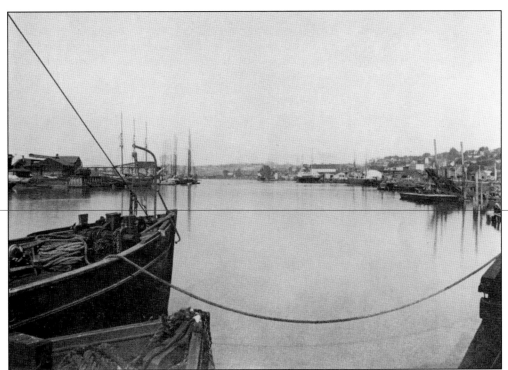

Richmond was established at the fall line of the James River, the farthest point inland that oceangoing vessels could navigate. The area was first explored by Capt. John Smith in 1607 and was briefly settled by the colonists in 1609. Rocketts Landing, seen here in 1895, was the first port of Richmond. Today, many of the warehouses along the old port have been converted into condominiums and restaurants.

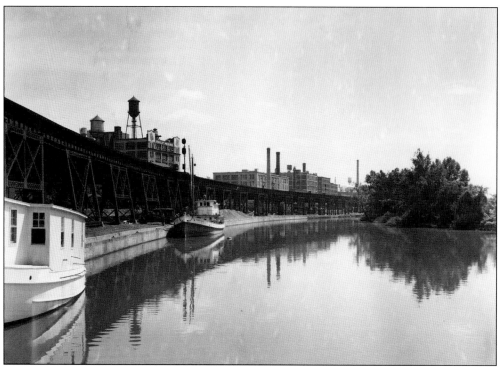

This photograph of the Great Ship Lock on the James River was taken sometime after 1935. The train trestle runs in front of the tobacco warehouses that once dominated the south end of Richmond's waterfront.

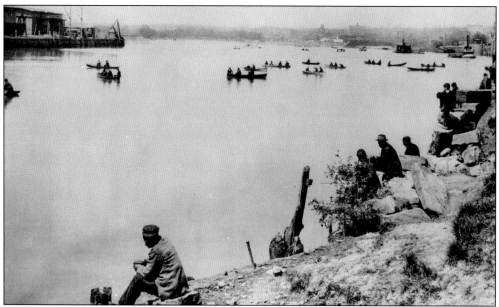

This image of people fishing in boats and along the banks of the James River was first published in 1897. The wharf in Richmond was one of the most important centers for commerce in the Colonial period, offering ocean access for the export of crops—especially tobacco and wheat—grown in the rich Virginia soil and for the importation of slaves from Africa.

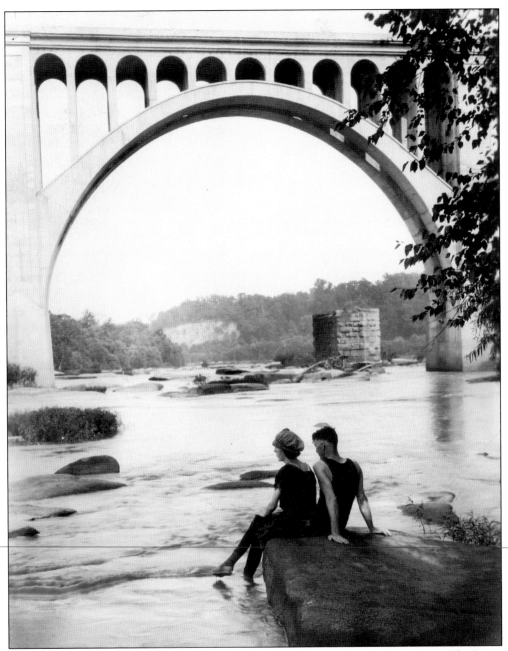

This arch, seen here around 1920, is part of a railroad bridge spanning the James River. The James River is still popular for recreation, with many areas preserved and maintained through the James River Park System and the James River Association. By the mid-1800s, the James River was an urban wasteland, contaminated by raw sewage and polluted by agricultural and industrial runoff. The James River Park System was founded in the 1970s, largely through donations of property and money from concerned citizens, and in 2009, a conservation easement was placed on several hundred acres of the park system for perpetual protection. Today, the James River Park System includes Belle Isle, wetlands, meadows, popular fishing areas, the historic Pumphouse, and part of the original James River Canal.

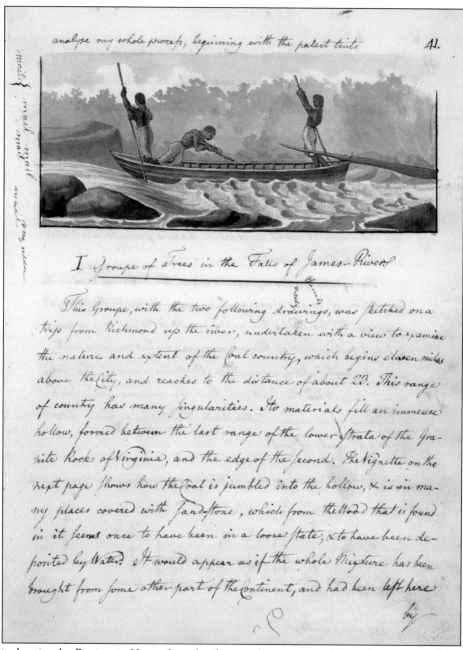

analyse my whole process, beginning with the palest tints

I Groupe of Trees in the Falls of James River.

This Groupe, with the two following drawings, was sketched on a trip from Richmond up the river, undertaken with a view to examine the nature and extent of the Coal country, which begins eleven miles above the City, and reaches to the distance of about 23. This range of country has many singularities. Its materials fill an immense hollow, formed between the last range of the lower strata of the Granite Rocks of Virginia, and the edge of the second. The Vignette on the next page shows how the Coal is jumbled into the hollow, & is in many places covered with Sandstone, which from the Wood that is found in it seems once to have been in a loose state, & to have been deposited by Water. It would appear as if the whole Mixture has been brought from some other part of the Continent, and had been left here by

This drawing by Benjamin Henry Latrobe depicts three men pushing a bateau up a sluice in the falls above Richmond. Between 1796 and 1798, Latrobe visited many sites in Virginia and his preserved sketches and journal entries provide invaluable historical information about life in Virginia during the late 18th century. Many of the buildings and places Latrobe sketched no longer exist or have changed dramatically over the centuries. The journal notes below this sketch read, "This Groupe, with the two following drawings, was sketched on a trip from Richmond up the river, undertaken with a view to examine the nature and extent of the Coal country, which begins eleven miles above the City." Latrobe goes on to describe the geography and geology of the region.

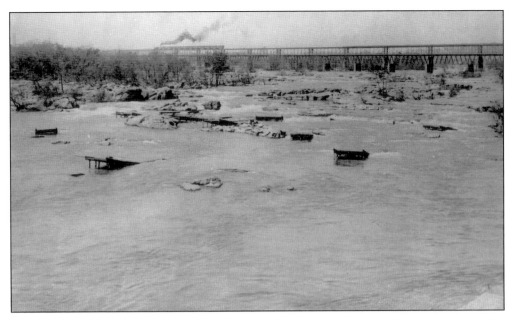

A train crosses one of the railroad bridges over the James River in 1897. By the end of the 1800s, the railroad had eclipsed shipping as the more cost-effective mode for transporting goods. Just 60 years later, in 1957, Interstate 95 would cut a scar straight through the city.

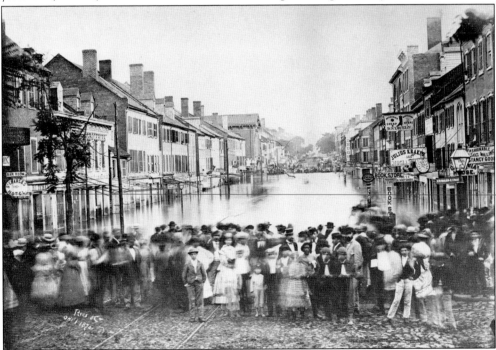

For the first two centuries after European settlement, the James River was the heart of commerce and trade in the Richmond region. Once dominated by tobacco warehouses and slave auction sites, the business district around Shockoe Slip was rebuilt after the burning of Richmond at the end of the Civil War. The Shockoe Bottom district is prone to flooding, as evidenced by this image captured in October 1870.

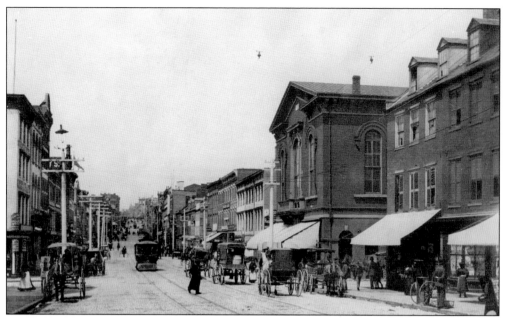

This view looks west along Main Street in the business district from Seventeenth Street and was published in *Art Work of Richmond* in 1897. Richmond was experiencing a period of rebirth in the late 1800s as it recovered economically from the Civil War.

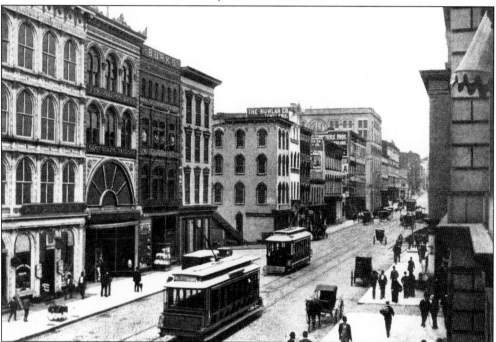

Richmond's electric trolley system, the Richmond Union Passenger Railway, was the most extensive and efficient of its kind when it began shuttling passengers in 1888. The trolley system linked downtown Richmond with the suburban housing communities on the north side of town, providing easy access for commuters. Electric trolley service was suspended in 1949. This view of the Main Street business district was published in 1902.

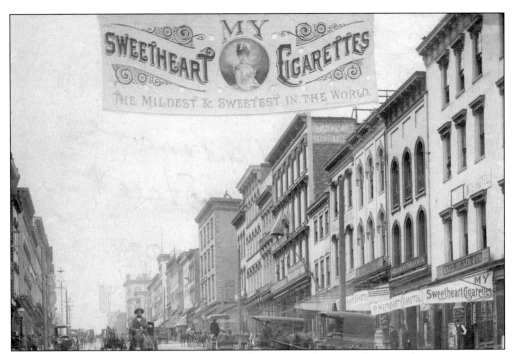

The Sweetheart Cigarettes banner spanning the street in this 1890 photograph is a testament to the importance of tobacco to Richmond's economy since the Colonial period. Today, Philip Morris, one of the largest cigarette manufacturers in the world, is still headquartered in Richmond. The tobacco warehouses that once lined the waterfront in Richmond were collectively called Tobacco Row. Some of the buildings have now been converted to condominiums and restaurants.

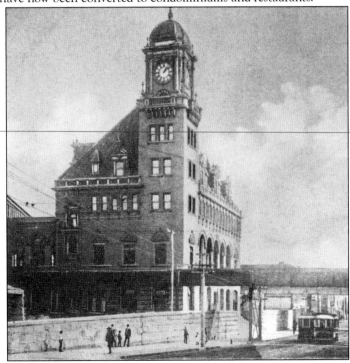

This photograph of Main Street Station from around 1920 shows the full building facade, which is now obstructed by the Interstate 95 overpass. Built in 1901, Main Street Station is in the National Register of Historic Places and was inactive as a functional train station for many years before being restored to service in 2003. The grand historic building is also used for office space, a visitor's center, and special events.

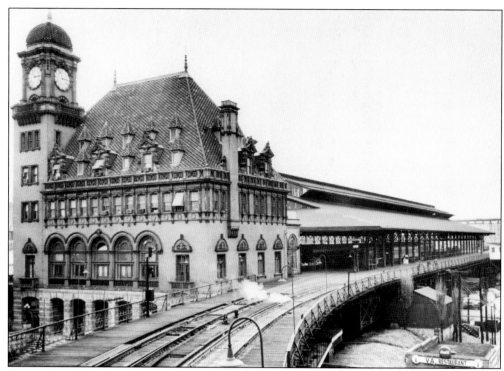

This undated photograph shows Main Street Station from the northeast. The tracks once curved off at Eighteenth Street to join a tunnel under Church Hill. The tunnel was excavated in 1873. In 1925, when it was being widened, the ceiling of the tunnel gave way suddenly, killing at least three people and burying a locomotive engine. The tunnel has been the subject of legends and ghost stories ever since.

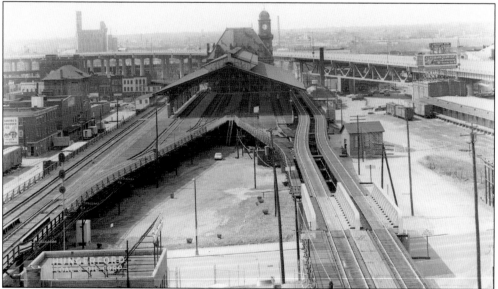

This view of Main Street Station shows the tracks entering the building from the north and was taken after the construction of Interstate 95 in 1957. The raised roadway of Interstate 95 bisects the clock tower in its march over Richmond's historic Main Street area.

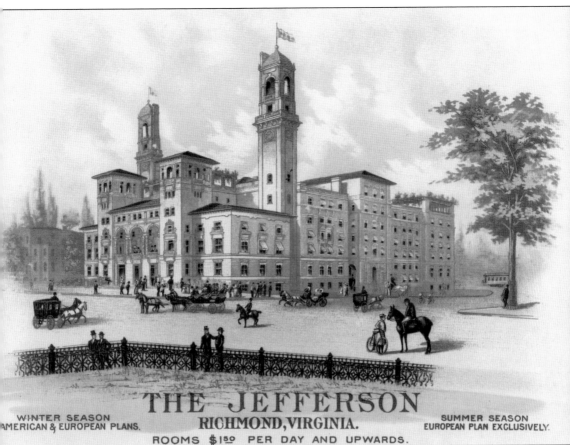

The Jefferson Hotel has had a long and checkered past, as it was rescued several times from decay and despair and suffered two great fires during its first century. The design and construction of the original Jefferson Hotel was conceived and funded by Richmond's famous adopted son, Lewis Ginter, an entrepreneur who made (and lost) his fortune several times in the import, tobacco, and banking industries. The Jefferson first opened in 1895 and is a classic example of the Beaux-Arts architectural school, an amalgam of Imperial Roman, Italian Renaissance, and Baroque styles that was popular in America in the late 1800s and early 1900s. This advertisement shows the rate for rooms at the hotel was "$1.50 per day and upwards." Today, rates begin at about $250 per night.

This street scene of West Franklin Street from the Adams Street intersection shows the Jefferson Hotel in the left foreground. This image was first published in *Art Work of Richmond* in 1897, only two years after the grand opening.

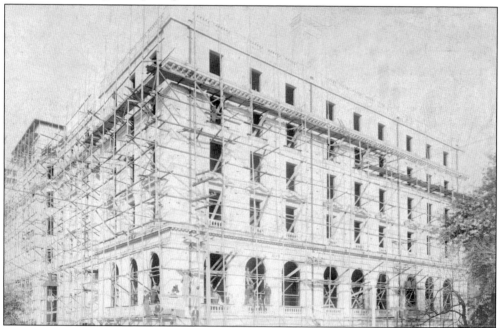

The planning and construction of the Jefferson Hotel took three years, with every detail overseen by Lewis Ginter. At the time of the grand opening in 1895, the Jefferson offered many amenities that were considered luxuries at the time, like electric lights, electric elevators, and hot and cold running water in every room.

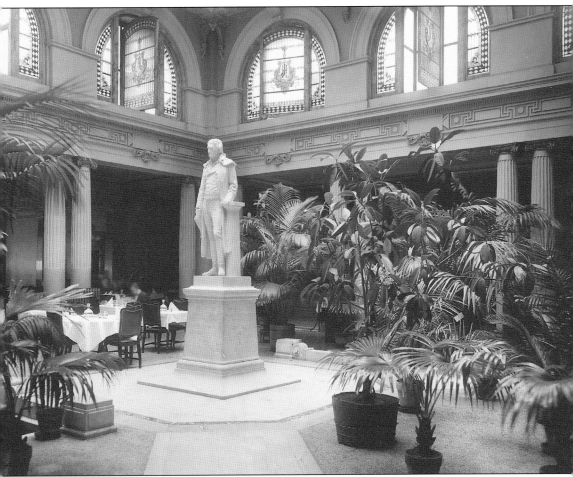

This statue of Thomas Jefferson in the Palm Court of the Jefferson Hotel was created by the celebrated Richmond sculptor Edward V. Valentine, whose brother Mann S. Valentine Jr. founded the Valentine Museum (now Valentine Richmond History Center). Edward Valentine was the creator of many celebrated works, including the Jefferson Davis statue on Monument Avenue, the statue of Gen. Williams Carter Wickham in Monroe Park, and *Recumbent Lee* in the Lee Chapel at Washington and Lee University in Lexington, Virginia. Until 1948, the marble pool in the Palm Court included live alligators, a source of many colorful stories from the hotel's history. In 1901, the Jefferson Hotel was almost destroyed by fire, but fortunately this statue was saved in a dramatic rescue. The sculpture was broken in the process, as the head was knocked clean off when the statue was dropped. Repairs were made by Valentine himself.

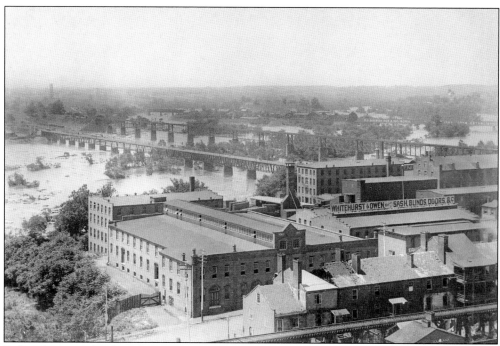

Belle Isle is an island in the middle of the James River in the heart of downtown Richmond. Now managed as a city park, the island has served as a fishery, an industrial site, and, during the Civil War, a prison for Union soldiers. Today, Richmonders frequent the tiny island for recreation, especially rock climbing and biking. Belle Isle is in the center of this photograph, two of Richmond's bridges passing over it.

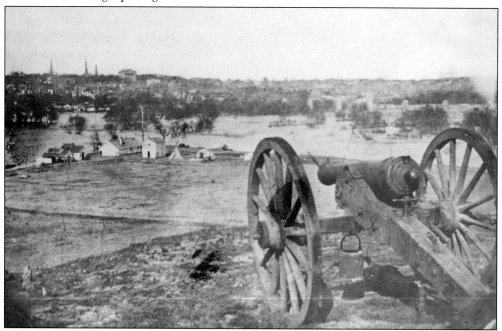

This view shows a piece of artillery overlooking the area used as a prison camp during the Civil War. The columned portico of the Virginia State Capitol can be seen in the distance at left center.

This view across Belle Isle is from under the Robert E. Lee Bridge, looking northeast toward downtown Richmond in 1955. There is now a footbridge suspended under the Lee Bridge with pedestrian access to Belle Isle. When the water level is low enough, the little island is also accessible by hopping from rock to rock across the James River.

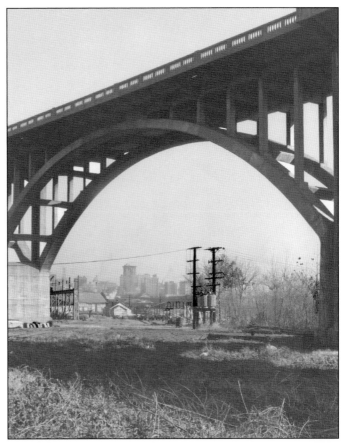

The illustration below shows Richmond from Belle Isle prison camp during the Civil War. The Virginia State Capitol is in the center, and the steeple of St. Paul's Church rises nearby as a train makes its way across the bridge and toward downtown.

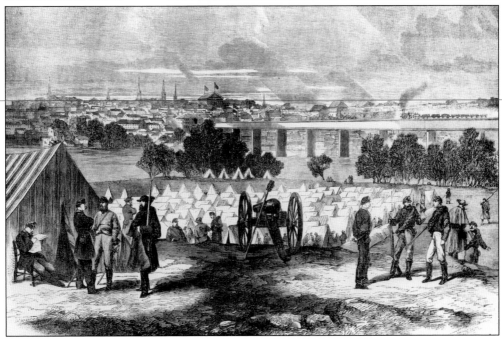

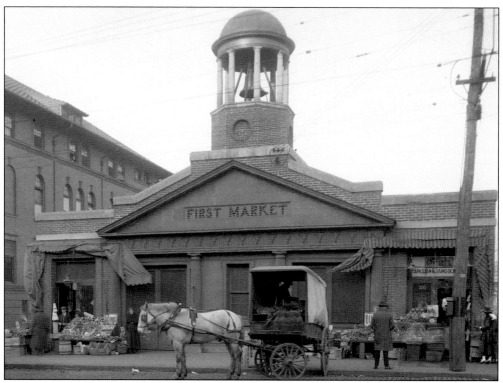

The site of the Seventeenth Street Market has been involved in public commerce since the founding of Richmond in the early 1700s. The building seen here, First Market, was expanded in the mid-1800s and served as a community gathering place and center of commerce well into the 20th century.

The interior of the First Market building at Seventeenth and Main Streets is seen here. Today, an open-air structure stands on the site and houses the Seventeenth Street Farmers' Market and weekend flea market. The market has been a center of Richmond society for almost 300 years.

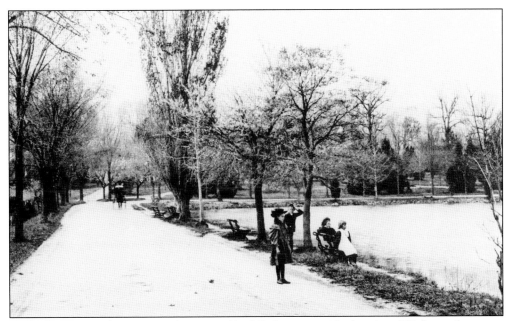

In the late 1800s, the area now known as Byrd Park was outside the city of Richmond, next to the site of the city's municipal water reservoir, which was constructed to provide sanitation and drinking water for the growing population. Fountain Lake in Byrd Park was artificially created by the excavation of earth used to reinforce the reservoir. Modern Byrd Park includes three small lakes and 200 acres of trails and recreation areas. This scene was published in *Art Work of Richmond* in 1897.

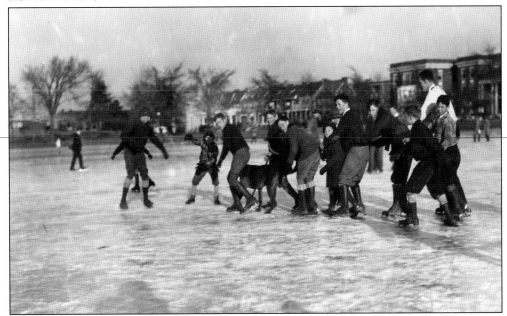

This frozen lake is in Byrd Park. Today, the park includes many amenities for residents and visitors, including an amphitheater, tennis courts, a baseball diamond, three lakes, and boat rentals. For the past few years, the City of Richmond has erected a temporary ice-skating rink downtown on Broad Street each winter.

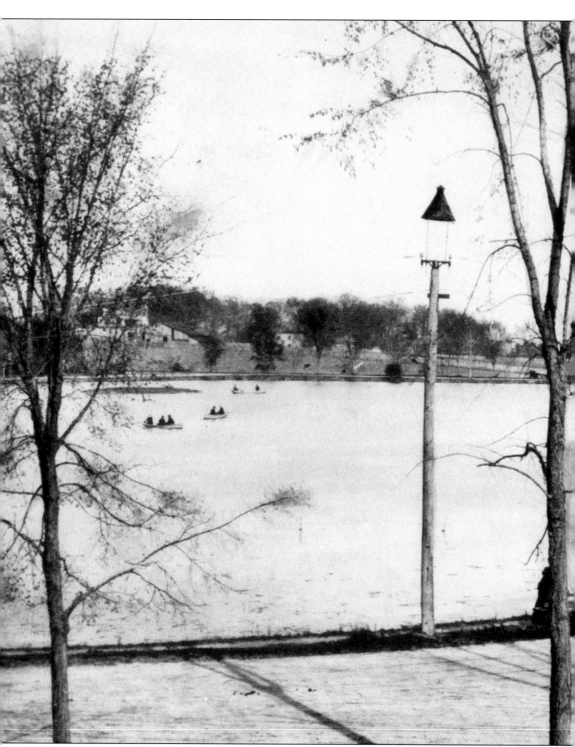

In 1883, a pump house was built to force water up from the James River to a reservoir built by the City of Richmond to provide drinking water for the city. The land for the reservoir was acquired in 1874 and was later transformed into a major park. Electric trolley service delivered residents from

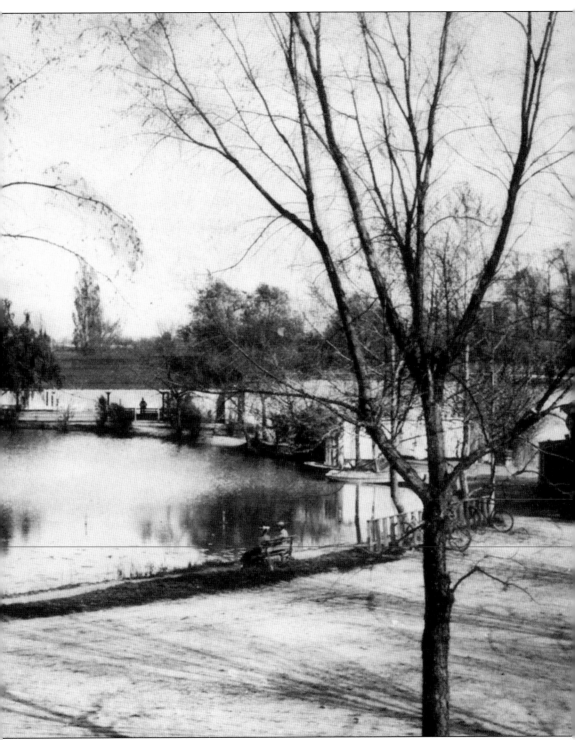

downtown Richmond to the park, where they could enjoy the natural splendor and river views. The original tract of land was about 60 acres but was expanded before 1900. This photograph of Boat Lake was taken in 1897.

The World War I Memorial Carillon was built in 1926 to honor those who fell during the war and features 56 bells, which are played on special occasions. Seen here on a mid-20th-century travel poster from the Chesapeake & Ohio Railway, the carillon was an important landmark luring travelers to Richmond.

Dogwood Dell Amphitheater in Byrd Park features plays, concerts, and the annual Festival of Arts celebration. The Festival of Arts has been an annual tradition in Richmond since 1956 and is hosted by the City of Richmond, with sponsorships provided by local corporations. The World War I Memorial Carillon is in the background.

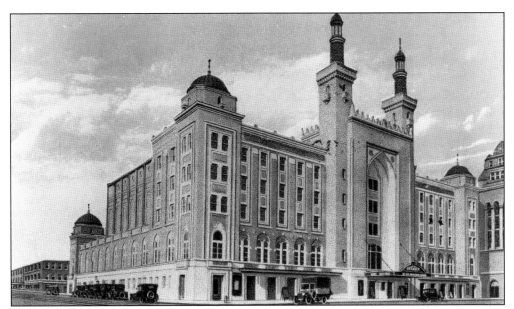

Located in the heart of Virginia Commonwealth University's Monroe Park campus and facing Monroe Park is the grand Landmark Theater. The Mosque Theater, as it was originally known, was built in 1918 by the Ancient Arabic Order of the Nobles of the Mystic Shrine (today known as Shriners), a fraternity organization related to Freemasonry. In 1940, the City of Richmond acquired the notable landmark, another shining architectural example of the city, and the theater now hosts hundreds of performances, meetings, and special events each year.

When the Byrd Theatre first opened in Richmond in 1928, the cost for tickets was 25¢ for a matinee and 50¢ for an evening show. Today, visitors can still catch any show for $1.99. This "Grand Movie Palace" includes opulent architectural details and an original Mighty Wurlitzer organ that once accompanied silent movies. Since 2007, the Byrd Theatre Foundation has been responsible for the preservation and operation of the theater.

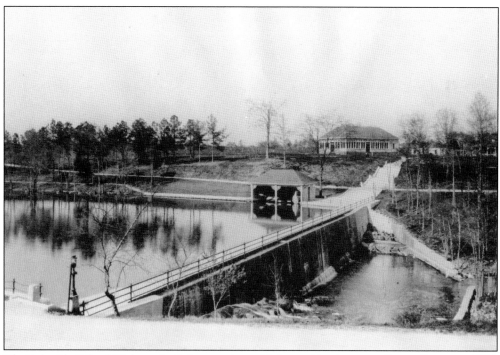

The Lakeside Wheel Club was built by prominent Richmond businessman Lewis Ginter in 1884. The Wheel Club was a destination for bicyclists who would ride from Richmond's city center and relax lakeside at the Wheel Club to recover from the long ride.

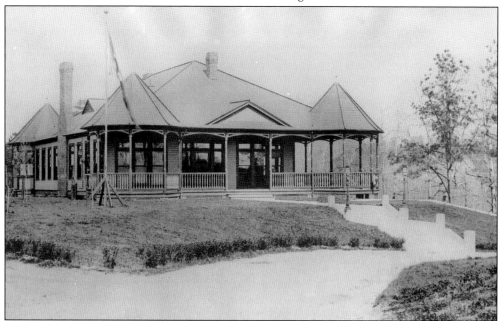

Lewis Ginter's Lakeside Wheel Club building was later converted into a convalescent home for sick children by his niece, Grace Arents. Once the convalescent home became unnecessary, Arents and her companion, Mary Garland, lived in the home. Bloemendaal House, as it is now known, is still preserved as part of the Lewis Ginter Botanical Garden.

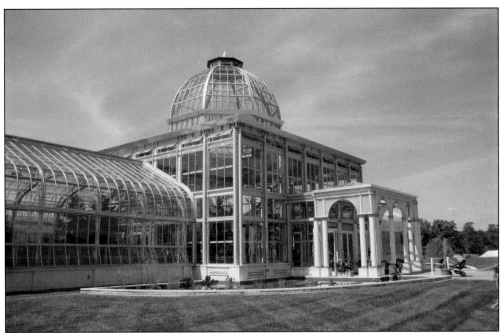

The Lewis Ginter Botanical Garden was made possible after Grace Arents bequeathed the property once owned by her uncle, Lewis Ginter, to the city. Though the property was left to languish for many years after it was donated, a group of interested citizens eventually took over the property to carry out Arents's dream of a botanical garden for the enjoyment of Richmond residents and visitors.

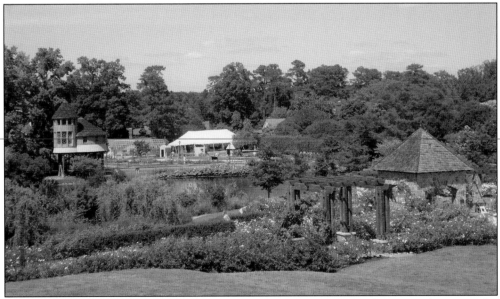

Appropriately, the Bloemendaal House, where Grace Arents once lived, is now adjacent to the children's garden, which includes a fully ADA-accessible tree house, fountains for play, playhouses, and an instructional garden, to the delight of Richmond's children. Arents cared deeply for the children of Richmond, providing generously for the care and comfort of some of the area's neediest children during her lifetime and beyond.

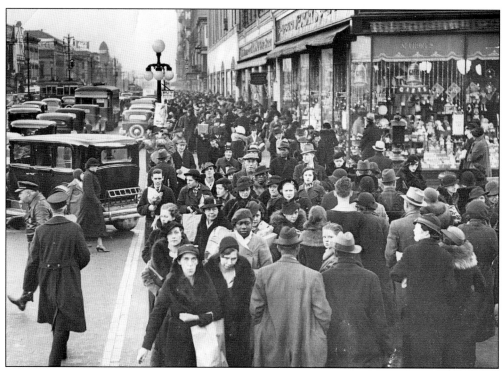

Broad Street, which borders Capitol Square to the north, runs through the heart of Richmond from its east end to its far west end. It is one the most recognizable features of Richmond, especially for those who only pass through Richmond via Interstate 95. In this image, shoppers crowd the downtown shopping district on Broad Street near Fifth Street in the 1920s.

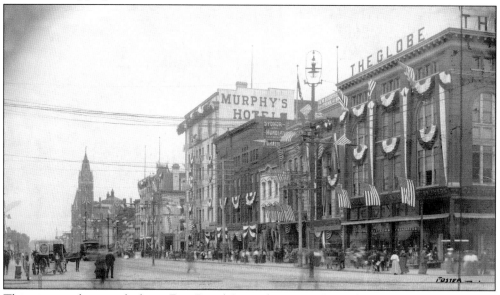

This vintage photograph shows East Broad Street from near Seventh Street around 1900. The tall tower of Old City Hall is in the distance. Around that time, the Broad Street commercial district included buildings in an amazing array of architectural styles, including an Art Deco skyscraper that was built in 1929.

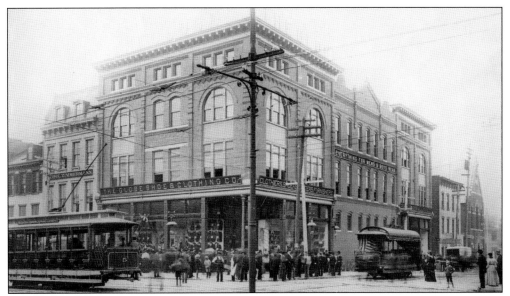

The Globe Shoe and Clothing Company, at the corner of Seventh and Broad Streets, is seen here between 1890 and 1900. The last of the grand department stores in downtown Richmond, Thalhimer's, also located at Seventh and Broad Streets, went out of business in 1992. The Thalhimer's Department Store restaurant, the Richmond Room, was the site of a 1960 sit-in protest against the segregation policy barring African Americans from dining there.

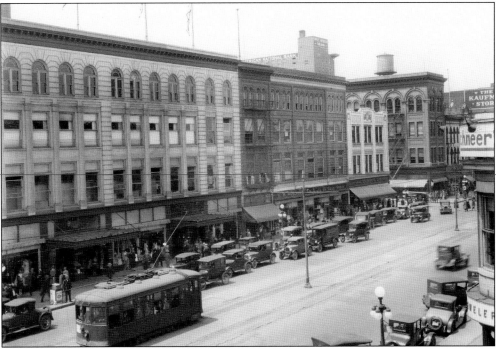

The south side of the 700 block of East Broad Street, an area once known as Theater Row, is seen here. National Theater, the last of its kind still in operation on this section of Broad Street, was built in 1923. Today, the National is a live-music venue and features performances from some of the biggest names in music.

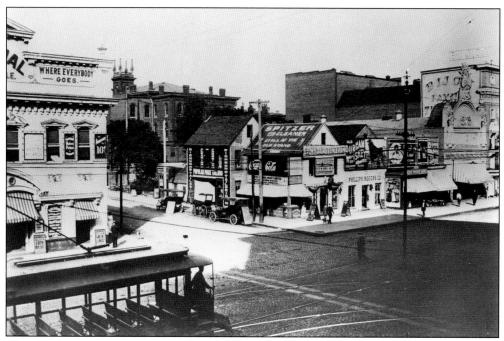

This 1905 photograph shows the 800 block of the north side of Broad Street. The entire city block is now devoted to the Library of Virginia's latest building, which has been its home since 1997.

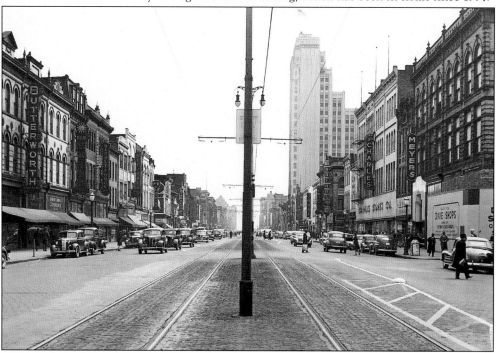

This view down Broad Street was taken in the 1940s from the corner of Foushee Street. By the 1940s, the streets of Richmond were dominated by cars and buses, and the electric trolley system was quickly waning in popularity. In 1949, the trolley system that had made Richmond so distinctive was abandoned altogether.

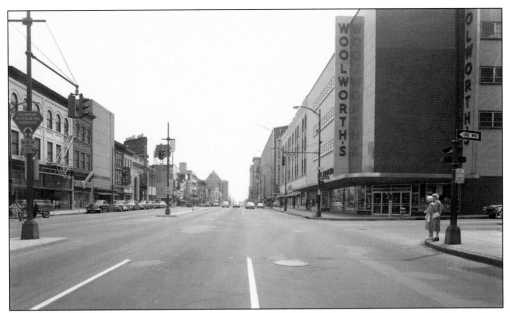

The Adolph B. Rice Studio Collection of photographs in the Library of Virginia provides a unique look at life in Richmond from 1949 through 1961. The collection consists of more than 16,000 negatives from Rice's commercial photography studio. This view of Broad Street from the 1950s was taken from the corner of Fifth Street looking east.

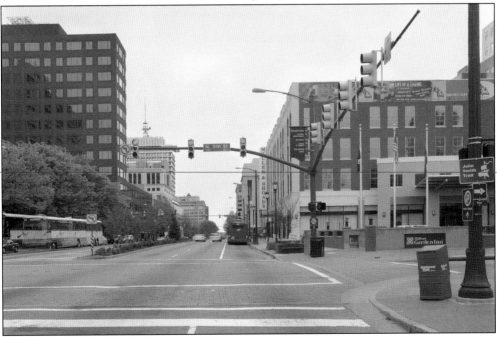

This photograph, showing the same intersection seen above, was taken in 2009 by the Library of Virginia's staff photographer Pierre Courtois. The sign for Miller & Rhoads Department Store can be seen on the right. The department store went out of business in 1990, and in 2008, the building was converted to a Hilton Garden Inn and condominiums. The sign remains to honor the 105-year history of the landmark store.

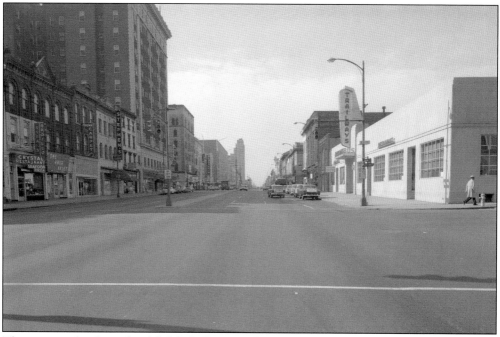

This image, also from the Adolph B. Rice Studio Collection, looks west down Broad Street from the corner of Ninth Street. Rice's studio was located on North Auburn Street in the neighborhood known as The Fan, which now encompasses the downtown campus of Virginia Commonwealth University.

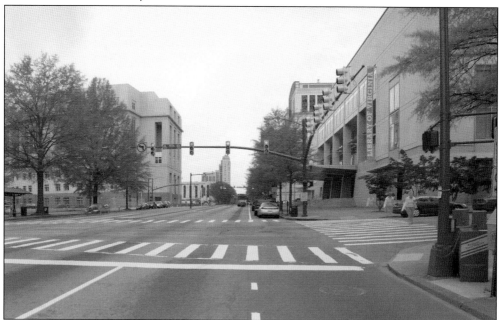

This 2009 photograph also looks west from Ninth and Broad Streets. The Library of Virginia spans the entire block between Eighth and Ninth Streets on the north side of Broad Street. The project of taking a modern image to match exactly the perspectives of the original Rice photographs was undertaken by Library of Virginia photographer Pierre Courtois in 2009.

Five

SEAT OF GOVERNMENT

In 2007, the Virginia State Capitol underwent a major restoration and expansion project. An underground addition was created to provide visitor access through Bank Street to the south and just downhill from the main capitol building. This conceptual drawing from 1973 shows how, even 40 years before it was actually completed, there was thought given to the capitol's eventual expansion. The 2007 expansion project left the historic landscape and views largely intact, unlike this ambitious conceptual redesign of historic Capitol Square, which features terraced concrete instead of the lush gardens and green space that are the square's trademarks.

This 19th-century etching of Capitol Square shows all of its important elements, including the George Washington equestrian monument, the Bell Tower, and the Virginia State Capitol prior to its first expansion in 1906. Capitol Square was enclosed by a wrought-iron fence in 1818, shortly after the first landscape plan was developed for the site in 1816. The landscape plan was

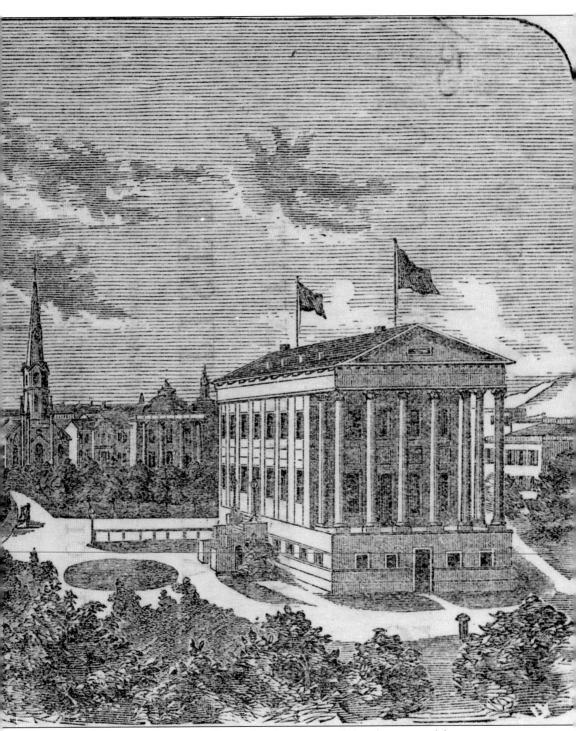

changed in 1850, incorporating winding paths, fountains, and the placement of the cornerstone for the Washington equestrian monument pedestal. Pres. Abraham Lincoln toured the grounds of Capitol Square in April 1865, shortly after the fall of Richmond at the end of the Civil War. This image shows Capitol Square as Lincoln saw it.

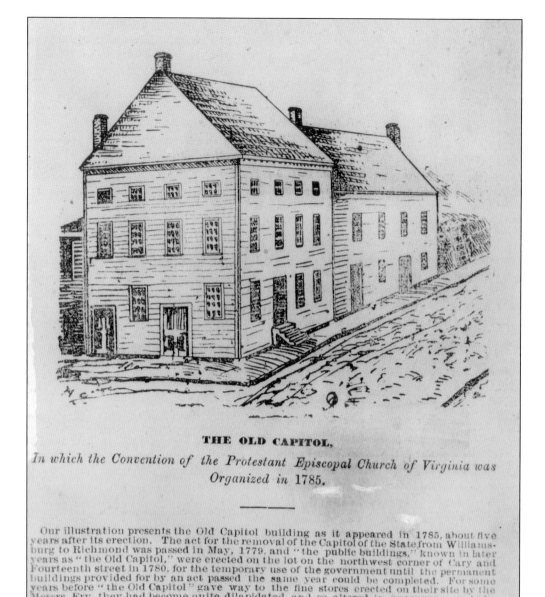

THE OLD CAPITOL,

In which the Convention of the Protestant Episcopal Church of Virginia was Organized in 1785.

This image shows the "Old Capitol" at the northwest corner of Cary and Fourteenth Streets. In 1779, the General Assembly voted to relocate the Virginia capital from Williamsburg to Richmond. Until 1788, when construction of the capitol building was completed on Shockoe Hill, this building served as the Virginia State Capitol. This building was originally a warehouse and was only ever intended to be a temporary home for the Virginia General Assembly. One of the first acts of the general assembly in its new capital city of Richmond was to name Shockoe Hill as the future site of the commonwealth's public buildings. At the same time, the nine-person Directors of Public Buildings, led by Thomas Jefferson, were put in charge of the planning and construction process. Jefferson was the driving force behind all of the committee's major decisions.

Taken in 1951, this image shows the site of the structure used as the Virginia State Capitol from 1780 to 1788. The building was demolished sometime before 1851 and all that remains is a commemorative plaque, which is next to the fire hydrant in the center of the photograph. The Virginia General Assembly originally envisioned the construction of a complex of public buildings, with separate structures to house the judiciary, legislative, and executive branches of the Virginia government. Records indicate that the general assembly found this plan to be financially out of reach, and by 1784, they had resigned themselves to the idea that all three branches would operate under the same roof.

This receipt was submitted by Thomas Jefferson to the Commonwealth of Virginia reporting his payments to the assistants of Charles-Louis Clerisseau, architect of the Virginia State Capitol. The report is dated December 1789. In 1786, Jefferson wrote a letter from Paris to the group he led, the Directors of Public Buildings, conveying his enthusiasm for the qualifications of Clerisseau and mentioning the Roman Imperial temple of Maison Carrée at Nimes, in southern France, as inspiration. In his letter, Jefferson discusses modifications to the 2,000-year-old design, which were borne of practicality but still troubled Jefferson. He felt that the temple represented artistic perfection and any deviation from the original would be regretted later. In this same letter, Jefferson also proposed the construction of a model to guide the planning efforts. The plaster model that resulted has been on public display for most of its existence and is part of the state art collection managed and maintained by the Library of Virginia.

Debourssé pour Monsieur Jefferson

les plants de prisons coupe et elevation — 2 Louis

les plants du model premier et Rez de Chaussé — 2 Louis

elevation de la facade — 2 Louis

Elevation Lateral — 2 Louis

les antiquités de nismes — 3 Louis

toutes les mesures et profil pour l'execution

d'un model — 1 Louis

12 Louis

il faut observer que tous les dessins
ont été obligé d'etre fait deux fois avant
de les dessiner proprement

J'as Certify that the above
Act Amot to 288 Livres

9 dec: 99

This document was Clerisseau's original bill to Thomas Jefferson, dated December 1789. The original document is in the archives collection of the Library of Virginia. Correspondence between Clerisseau and Jefferson during the planning process for the Virginia State Capitol reveals that, from the very first, Jefferson wanted to re-create, in Richmond, a classic example of an Athenian temple upon a hill. Jefferson named several temples in his correspondence with Clerisseau but finally fixed on the Maison Carrée as his inspiration. Jefferson not only had a vision for how he wanted the exterior to appear, but he also knew how he wanted the interior rooms arranged and what their functions should be. The interior design closely resembles that of the Second Capitol in Williamsburg, a building that was very familiar to Jefferson. The resulting building was a classic temple with a central chamber in which the Houdon statue of George Washington is presented in a manner suitable for a god or some other mythological hero.

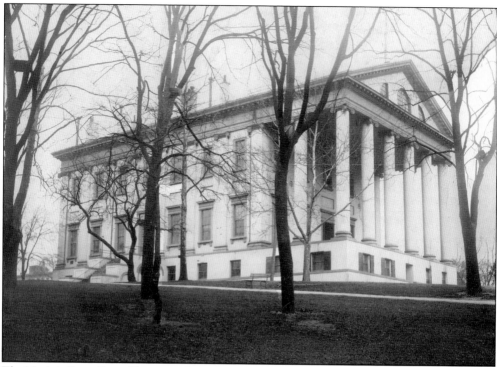

The Virginia State Capitol has gone through two major expansions, the first in 1906 and the second in 2007. The first expansion added wings, or "hyphens," to either side, providing a chamber each for the Virginia House of Delegates and the state senate. The second expansion was completed underground, adding meeting space, an exhibition gallery, a visitor's entrance, and a gift shop. The capitol is seen here in 1897.

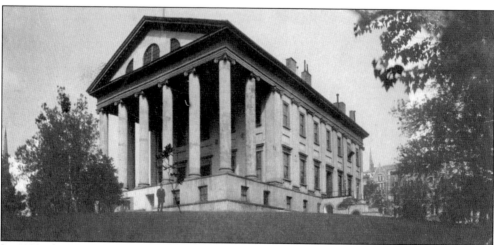

In 1902, the Virginia General Assembly appropriated $100,000 to fund much-needed repairs and improvements to the capitol. Even at the time, the general assembly was sensitive to the historic nature of the building and required that the general design be preserved. At that time, architectural firms were invited to submit proposals for expanding the capitol that would include upgrades for the safety of the structure and the people within it.

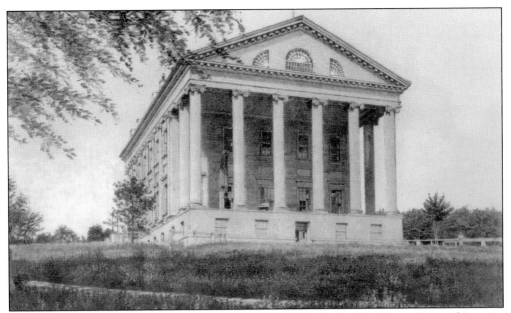

The Virginia State Capitol was used throughout the Civil War by the Confederate States of America government. As the Confederate troops fled Richmond in April 1865, they were ordered to burn the factories and warehouses to keep the stores out of the hands of the Union. The Virginia State Capitol, the Executive Mansion, and the White House of the Confederacy were spared from the burning, which destroyed much of downtown Richmond. The capitol is seen here in May 1865, just after the fall of Richmond.

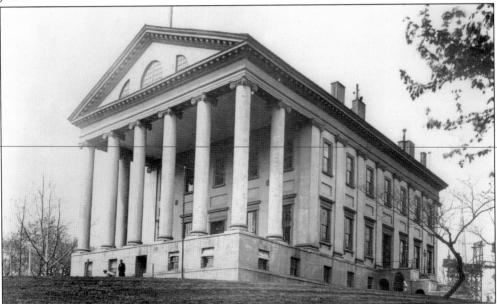

This photograph of the capitol was taken in the 1890s, a period of unrest in Virginia politics. Women's suffrage, racial injustices, and the lack of social safety nets for the poor were some of the major issues during the post-Reconstruction period. New voting laws created at that time were designed to disenfranchise African Americans and poor whites because, together, that portion of the population vastly outnumbered the elite whites who designed and enacted the laws.

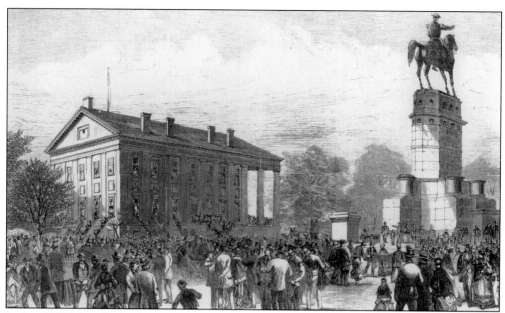

In April 1870, hundreds of people crowded into the Virginia State Capitol to hear the decision of the court of appeals about a scandalous lawsuit. The floor of the court chamber gave way under the massive weight of the many spectators, taking with it the observation gallery above. More than 50 people were killed and another 100 or more were injured when the floor collapsed into the Virginia House of Delegates chamber below.

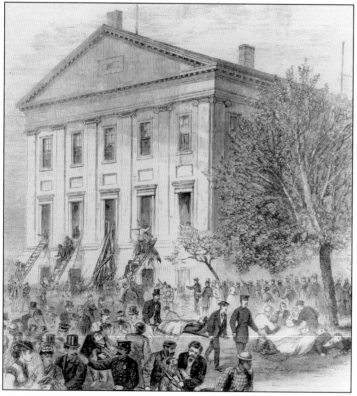

Sensational images such as this one, published in *Leslie's Illustrated Newspaper,* and the image above, published in *Harper's Weekly,* were distributed widely as the news about the tragedy in Richmond spread. The room in which the court proceedings were held was a later addition, added to divide one high-ceilinged room into two rooms, one above the other. Poor design and nonexistent building codes were as much to blame as the overcrowding of the space.

This is an interior view of the senate chamber in the Virginia State Capitol. Note the ashtrays on every desk in the room, showing that this photograph was taken in a different era. The state senate consists of 40 members who serve four-year terms.

The Old Hall of the House of Delegates is where the treason trial of Aaron Burr was held, presided over by John Marshall. It is also where the delegates deliberated over whether Virginia would secede from the Union in 1861. This photograph was taken in 1938, and the space has since undergone restoration.

The General Assembly is seen here in session in the Old Hall of the House of Delegates in 1932. Note the microphone from WRVA, the "Voice of Virginia," a Richmond AM radio station that has been in the talk radio business since 1925.

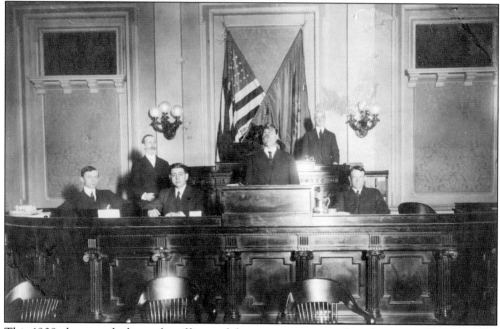

This 1908 photograph shows the officers of the state senate seated in the senate chamber. The members of the general assembly are in their Richmond offices when in session—January through March in long-session years; January through February in short-session years—and serve the rest of the year out of their local district offices.

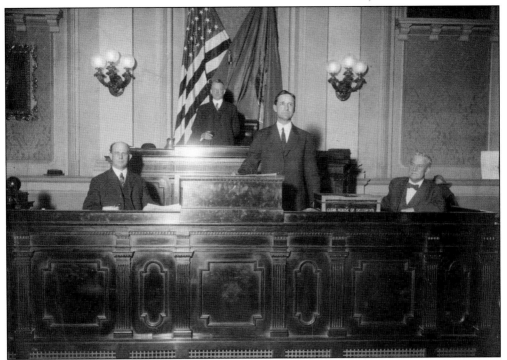

The officers of the Virginia House of Delegates are seen here in 1910. There are 100 members of the House of Delegates, each representing an equal number of constituents. Delegates are paid $17,000 per year to serve in office and must be in Richmond during the legislative session each winter. The House is led by a speaker, who is elected from the majority party.

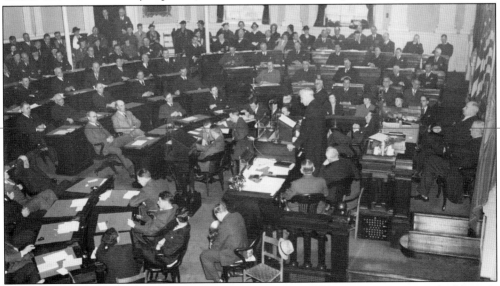

The Virginia House of Delegates, seen here in session in 1938, traces its roots to the Virginia House of Burgesses, which was created by the Virginia Company in 1619. Through this legislative body, the colonists self-governed, with a representative elected from each region. Over time, the English Parliament revoked some of the rights of the colonists, especially through taxes under the Sugar and Stamp Acts, which led the colonists to revolt.

This portrait gallery and balcony are located on the third floor of the rotunda in the Virginia State Capitol. At the bottom, on the far left, is a portrait of Patrick Henry, one of the most famous portraits in the Virginia state art collection, which is managed by the Library of Virginia. Many of the sculptures and paintings owned by the commonwealth are on display in the capitol and in the Executive Mansion.

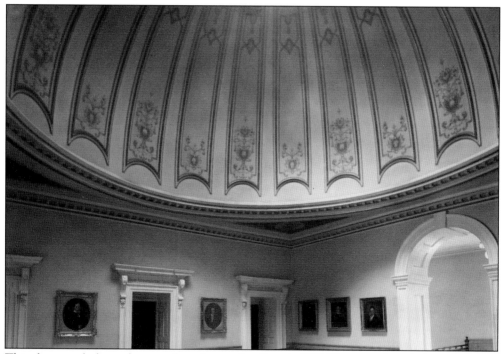

This photograph shows the rotunda and portrait gallery in 1937. The rotunda includes niches with busts of seven Virginia-born presidents—George Washington is the eighth—and the Marquis de Lafayette. Lafayette was a hero of the American Revolution and great friends with many of the founding fathers, who owed him a debt of gratitude for his service in partnership against the English.

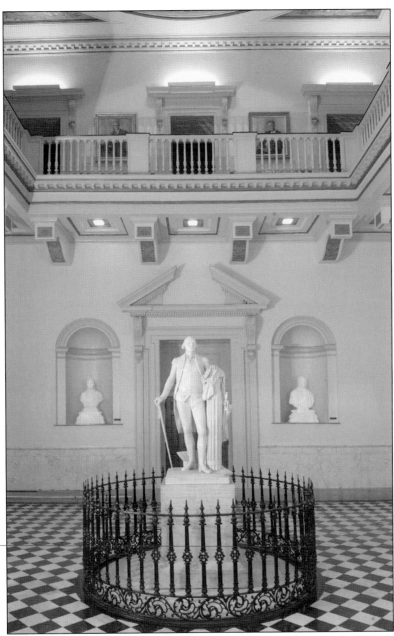

In 1784, while planning for the new permanent capitol was underway, the Virginia General Assembly commissioned a statue of George Washington. Thomas Jefferson, who was living in Paris at the time, was asked to find a suitable sculptor. Jefferson engaged Jean-Antoine Houdon, a well-known French sculptor who had previously completed portrait sculptures of Voltaire, Jean-Jacques Rousseau, and Benjamin Franklin (Franklin served as ambassador to France from 1776 to 1785). Houdon's works can be seen in the National Portrait Gallery in Washington, DC, and at the Metropolitan Museum of Art in New York City. Houdon's statue of Washington was finished before the capitol was complete and was kept on display in the Louvre until it was relocated to Richmond in 1796. Based on comments from Washington's contemporaries, the Houdon statue is the closest known likeness to George Washington.

A landmark that does not get much attention is this granite marker, the zero milestone for measuring highway distances from Richmond. It is just to the north and west of the capitol on Capitol Square and was put in place in 1929. The marker is located at north latitude 37° 32' 23" and west longitude 77° 26' 04" at an elevation of 166.45 feet above sea level. The marker also includes an inscription declaring that it was donated by Jonathan Bryan. The zero milestone in Washington, DC, for measuring all distances from the nation's capital was placed in 1919 on the Ellipse in Washington. In the decade that followed, many states followed suit and erected their own zero milestones. The zero milestone was a Roman invention; they placed milestones along all roads leading to Rome.

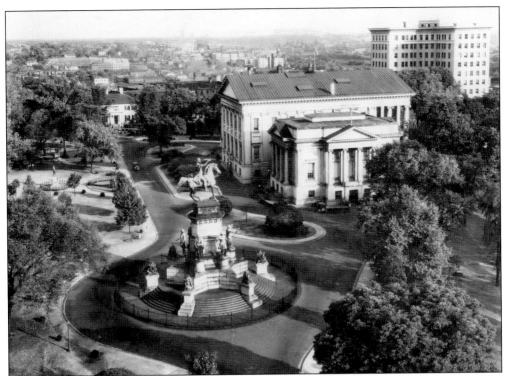

Thomas Crawford's design for a monument honoring George Washington was commissioned in 1849 by the Virginia General Assembly. The cornerstone for the granite base of the Washington Monument was put in place on Washington's birthday, February 22, 1850. Eight years later, the 18,000-pound statue was unveiled, also on February 22.

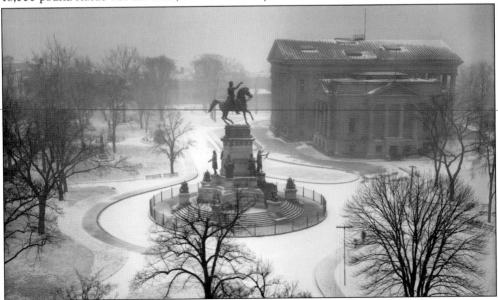

Harry C. Mann took this photograph of the George Washington Monument in the snow in 1915. Mann's photographs are well known in Virginia, and this is one of the most iconic images he ever captured. Another Mann photograph is on the cover of this book.

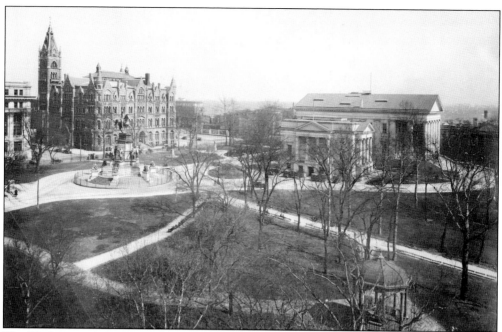

The Washington Monument has three tiers—Washington on the top tier, six prominent figures from Virginia's past on the second tier, and on the third tier, six allegorical figures representing the corresponding statue of the person above it. Designer Thomas Crawford died before the monument was put into place and before completing all of the supporting figures. Another artist completed the remaining figures, the last of which was put into place in 1869.

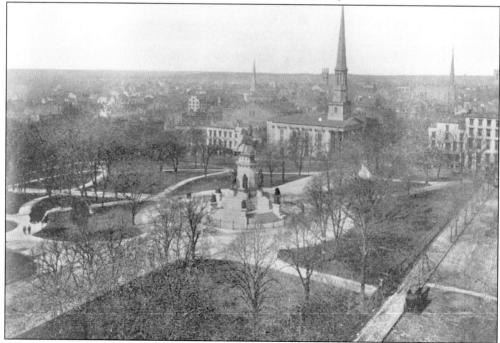

This photograph of the Washington Monument was taken sometime before 1900, evidenced by the tall, pointy steeple of St. Paul's Church, which was replaced after a hurricane in 1900.

Three construction workers stand on girders with the capitol in the background. This photograph was taken in 1909 and was dated by photograph catalogers at the Library of Virginia based on the construction dates of the building across Bank Street from the capitol.

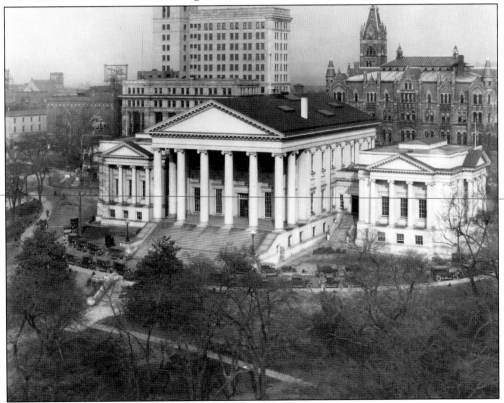

The driveway in front of the capitol is lined with cars in this 1936 photograph. The capitol grounds are no longer accessible by car; the sweeping driveway in the front is now for pedestrians only.

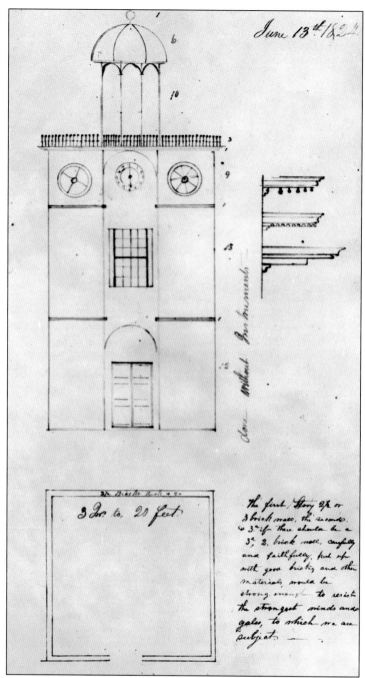

The following text appears within the drawing:

June 13th 1824

3 Bro. to. 20 feet.

Class Without Instrument

The first Story 2½ or 3 brick wall. the seconds. & 3d if there should be a 3d. 2 brick wall. carefully and faithfully. put up with good bricks and other materials, would be strong enough to resist the strongest winds and gales, to which we are subject —

The Bell Tower stands at the southwest corner of Capitol Square. It was built in 1825 for use by the Virginia Public Guard and was adjacent to their barracks. The Virginia Public Guard traced its roots to the Jamestown settlement, which created a force of men in 1618 to protect the governor against Indian attacks. The Virginia Public Guard would later become the Capitol Police, who still guard the capitol and other state-managed buildings in Richmond today. The police force has grown to include a K-9 unit, investigative services, emergency medical technicians, and regular patrols. This drawing, dated June 1824, was a design proposal submitted during the planning process.

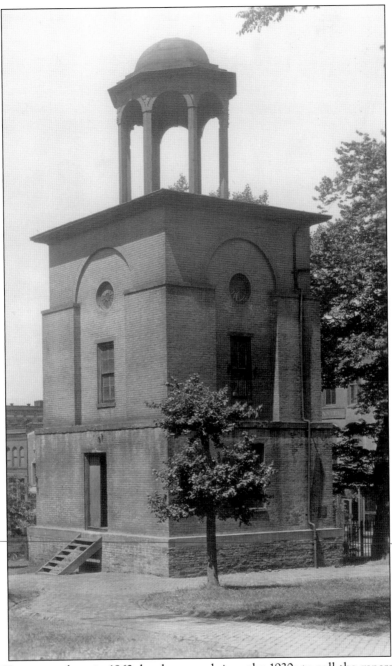

The Bell Tower, seen here in 1962, has been used since the 1930s to call the general assembly into session each day. The bell was rung during the Civil War to warn Richmond residents of the approach of Union troops, most notably to alert the city at the time of Dahlgren's Raid in 1864. From 1978 to 1982, the building served as an office for Gov. Charles Robb and for the Capitol Square Preservation Council. Today, the Bell Tower houses a visitor's center with information about the entire state and is operated by the Virginia Tourism Corporation. The fountain in front of the Bell Tower was originally installed in the 1850s. The current fountain is a replacement that came from the home of Westmoreland Davis, the governor of Virginia from 1918 to 1922.

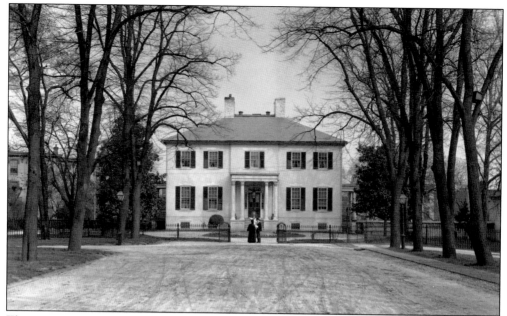

The governor's mansion—better known as the Executive Mansion—was completed in 1813 and has housed Virginia's governors and first families ever since. The photograph on the cover of this book was taken just in front of the mansion, with the trademark heron fountain just visible over the windshield of the car. This photograph was taken in 1910, and the original is in the collection of the Library of Congress.

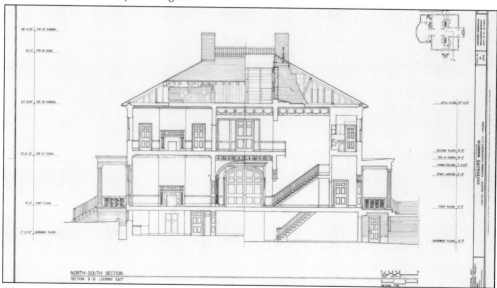

This architectural drawing of the Executive Mansion was completed as part of the Historic American Buildings Survey (HABS), an important project of the National Park Service to document American architectural heritage. HABS was initiated in 1933 as a New Deal make-work program for photographers, architects, and draftsmen. The detailed records created through HABS are invaluable research tools for historians, especially architectural historians conducting renovations and reconstructions of historic buildings. This image was drawn in 1987; the original survey is on repository in the Library of Congress.

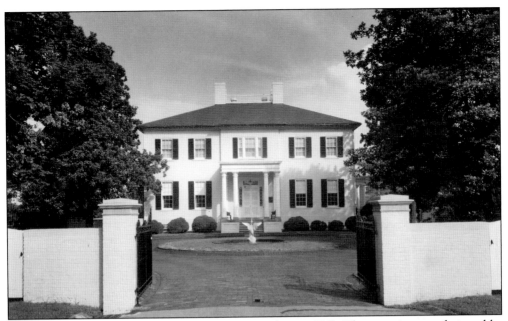

This photograph of the Executive Mansion was taken in 1961. The mansion was designed by Boston architect Alexander Parris and includes a balustrade that connects its four chimneys and a columned portico, which gives the house its distinctive facade.

This doghouse in the garden of the Executive Mansion was made to resemble the Virginia State Capitol before its 1906 expansion. The doghouse was a gift to Gov. Gerald L. Baliles, who was governor from 1986 to 1990. The photograph was taken in 1988.

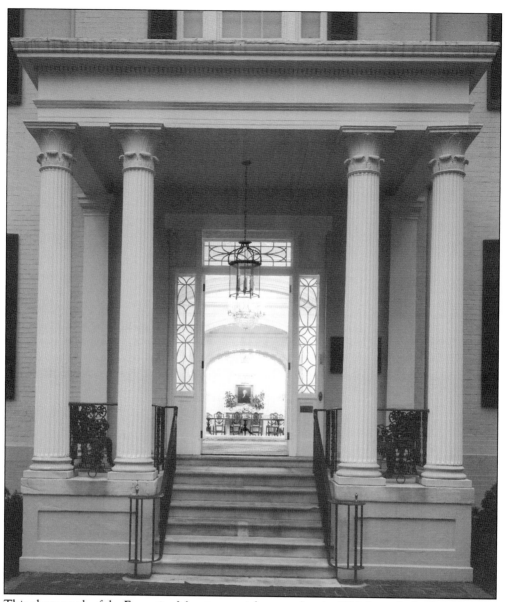

This photograph of the Executive Mansion at night was taken in 1988 through the front portico. The mansion was built between 1811 and 1813 and was expanded in 1906, at the same time the capitol underwent its first major expansion. The 1906 renovation added a large ballroom and modified some of the public rooms. The governor and the first family occupy the private rooms on the second floor. In 2007, Queen Elizabeth II visited the Executive Mansion as part of her tour of Virginia during the celebration of the 1607 founding of the commonwealth in Jamestown. Famous Virginians who have lain in state in the Executive Mansion include Stonewall Jackson, Oliver Hill, and Arthur Ashe.

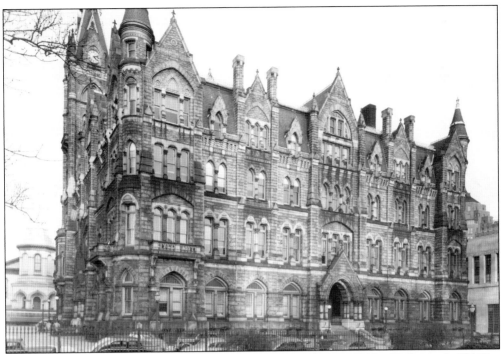

This fabulous example of Gothic Revival architecture, seen here in 1946, is Richmond's Old City Hall, located just north of and overlooking the Virginia State Capitol. Opinions are divided on the appeal of the building, as some people respond negatively to the gray stone structure and its major force of personality. The building served as Richmond's city hall from 1894 until the 1970s and is one of many Richmond structures in the National Register of Historic Places.

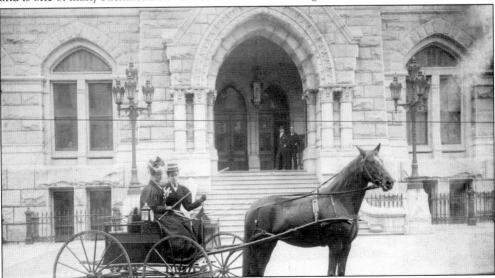

The entrance to Old City Hall is seen here in 1895 behind this horse and buggy. The colossal building has been threatened with demolition in the past, in 1915 and again in 1971 after it was no longer used for its original purpose. Preservation of the building is now guaranteed because of its classification as a National Historic Landmark. It has also been thoroughly documented in the Historic American Buildings Survey.

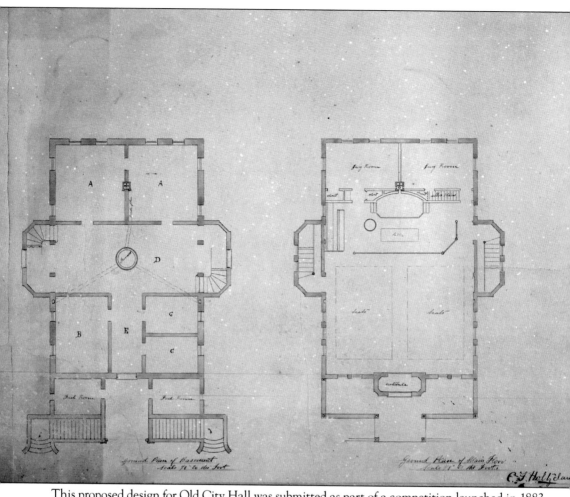

This proposed design for Old City Hall was submitted as part of a competition launched in 1883 and is dated 1884. The Old City Hall is an incredible representation of Gothic architecture, a symbol of rebirth and renewal as Richmond emerged from the horrors of the Civil War and rebuilt the downtown around the centerpiece of Capitol Square. The building was constructed between 1887 and 1894 with some of the most cutting-edge materials available at the time. When the building was slated for demolition, it was acquired by the State of Virginia, with help from the Historic Richmond Foundation, and renovated. Historic preservation did not become a major priority for states and municipalities until the 1970s, when adaptive reuse came into vogue. Many of Richmond's historic sites and museums now make a significant contribution to the local economy.

A man sits on the roof of Old City Hall looking down over the city in this undated photograph. The new city hall—one block to the west and across the street—includes an observation deck that is open to the public and provides panoramic views of the city.

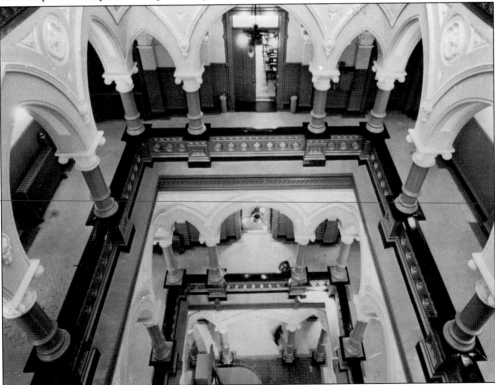

The interior design of the Old City Hall rivals the exterior in its showiness. The central atrium is lit by natural light and features a magnificently painted, multistory arcade of decorated columns. The first floor is open to visitors, though the rest of the building is now used as private office space.

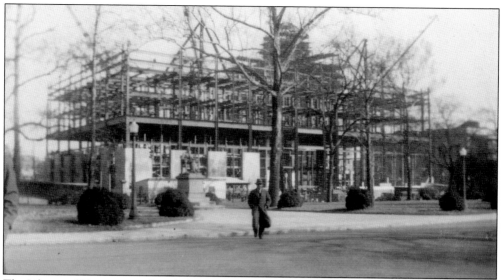

The Library of Virginia was founded in 1823 to maintain and preserve the historic record of the commonwealth. It outgrew two locations before a new building was erected on the north side of Capitol Square adjacent to the Executive Mansion and Richmond's Old City Hall. Here, the third location is under construction in 1939.

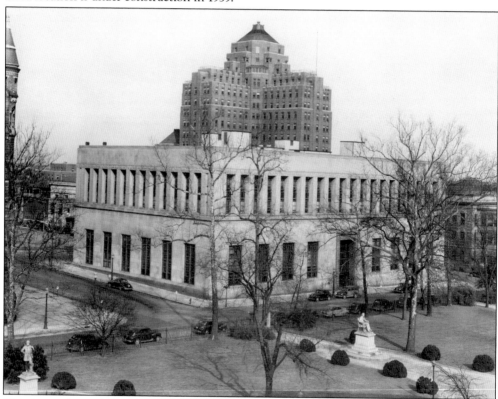

This image shows the completed third location of the library, which it occupied from 1940 until 1997, when a new structure was opened at 800 East Broad Street. In the background, the Medical College of Virginia hospital building looms over the library.

Six

THE GREATER
RICHMOND REGION

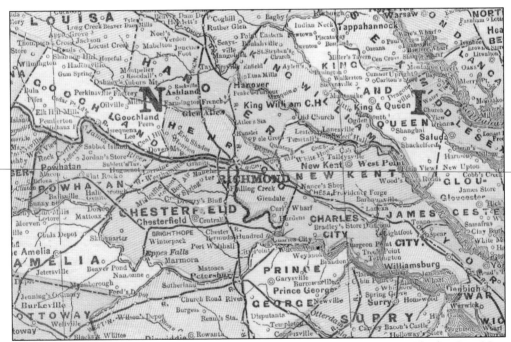

Richmond is surrounded by the counties of Henrico, Chesterfield, Hanover, Charles City, New Kent, Powhatan, and Goochland. The 2010 population of the City of Richmond was about 200,000, while the metropolitan area is home to almost 1.3 million people. In 1790, at the time of the first US census, Richmond had a population of 3,700.

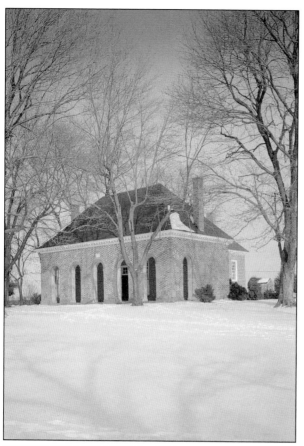

Hanover Courthouse, the seat of Hanover County, is about five miles north of the northern border of the city. The original courthouse (left) was built around 1735 and was where Patrick Henry argued the famous "Parson's Cause" before a jury in 1763. The building is no longer used for official business but is used for occasional weddings. Each year on Historic Hanover day, there are reenactments of the Parson's Cause in the courthouse.

Hanover Tavern (below) was part of the original Hanover courthouse complex. The oldest section of the existing structure dates to 1791, but there was an earlier tavern building on or close to the site. Barksdale Theater, Virginia's first theater to defy Jim Crow laws and welcome integrated audiences, was established at the tavern in 1953. Today, the Hanover Tavern is operated as a museum and includes a full-service restaurant and a theater.

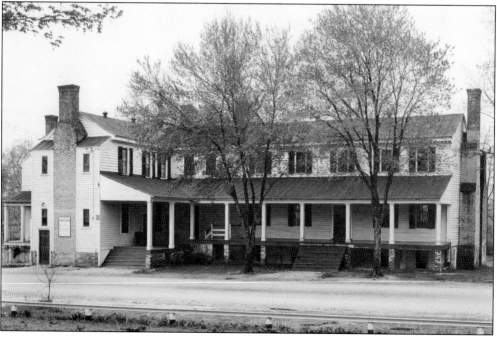

The town of Ashland, about 15 miles north of Richmond, was established in 1840 but not officially founded until 1858. It has been quaintly dubbed "The Center of the Universe" by local residents and is home to Randolph-Macon College.

Ashland is the quintessential railroad town and actually owes its founding to the Richmond, Fredericksburg & Potomac Railroad, which established Ashland as a mineral springs resort in the 1840s. The railroad tracks run right through the middle of town, with a small platform station that houses a visitor center. This photograph was taken in the 1950s.

The Richmond National Battlefield Park, part of the National Park Service, is comprised of many sites around Richmond related to the Civil War. The park system includes the Tredegar Iron Works and the Chimborazo Medical Museum within Chimborazo Hospital. In all, the park includes over 1,900 acres.

The aerial view below was taken in 1954 to show the Union fortification known as Fort Brady, an earthworks fort overlooking the James River. The site is now part of the Richmond National Battlefield Park and includes a trail with markers and some of the original earthworks.

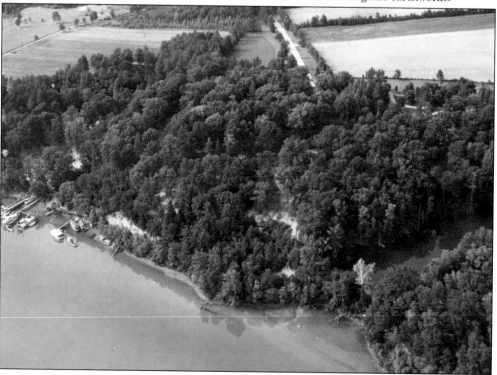

The image at right clearly shows the remnants of Fort Johnson in Henrico County, Virginia. The undulating ground may appear to have occurred naturally but these are actually old fortifications called earthworks. This site is also under the protection of the National Park Service as part of the Richmond National Battlefield Park system.

Drewry's Bluff (below), the site of Fort Darling, which overlooks the James River, was an important strategic stronghold for the Confederate army. Fort Darling was established as a defensive measure to protect Richmond by water from the Union navy. This photograph, taken in 1954, shows the view from Fort Darling looking east along the James River. The site is preserved as part of the Richmond National Battlefield Park.

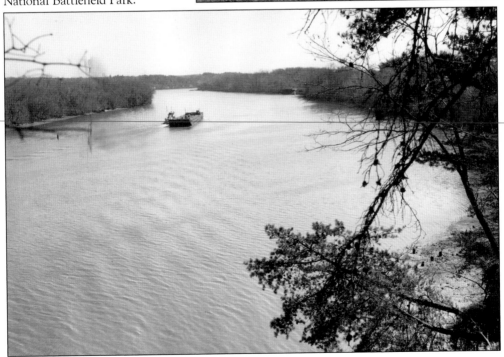

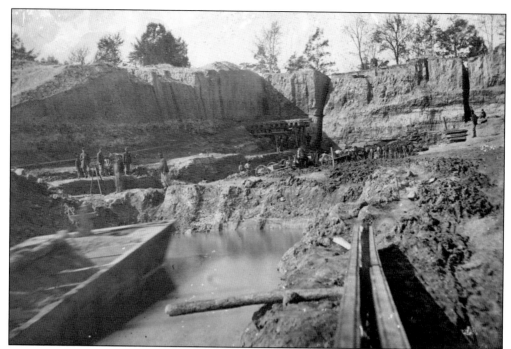

The James River near Henricus was a focal point for the Union army's offensive plan during the Civil War. The Union devised a plan to cut a canal through the area known as Dutch Gap in order to bypass a five-mile loop of the James River that was heavily fortified with Confederate artillery. Construction of the canal began in August 1864 and was largely dug by the physical labor of black Union regiments.

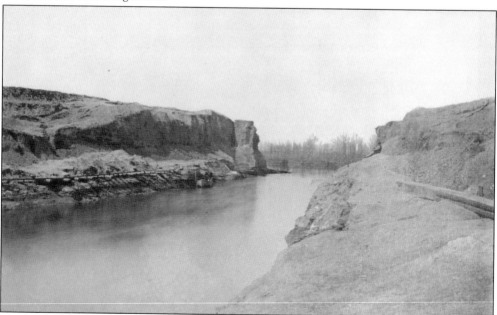

This image shows the completed Dutch Gap Canal in March 1865, just before the end of the Civil War. Though the canal was completed before the end of the war, it was not deep enough to allow passage of military warships. The canal is now part of a large conservation area.

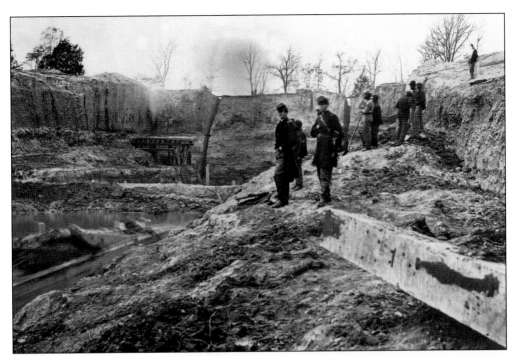

Above, Union soldiers pose along the Dutch Gap Canal construction area as the workers behind them hold some of the simple tools used to complete the massive undertaking. Some blasting and a steam dredge were used to carve the canal, but it was largely created from the manual labor of black regiments.

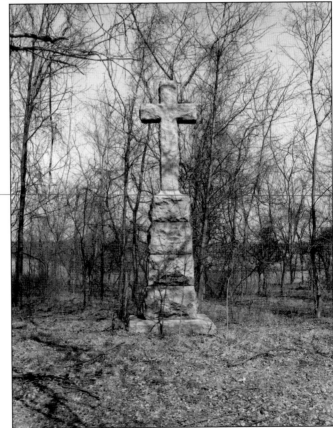

This stone cross was erected in Henricus in 1911 to commemorate the founding of the Episcopal Church in Henrico Parish in 1611. Henricus was the second English settlement in Virginia. Pocahontas was taken prisoner by the English settlers in 1613 and later held captive by Alexander Whitaker at the Henricus site. Today, Henricus is operated as a living history museum.

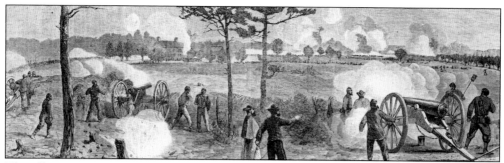

This illustration was published in *Harper's Weekly* in 1864 and depicts Union artillery in action at Cold Harbor, a battlefield in Hanover County that is now part of Richmond National Battlefield Park. Cold Harbor was one of the final battles in General Grant's overland campaign to capture Richmond.

A child plays in the remains of the trenches of Cold Harbor Battlefield in 1958. Gen. Robert E. Lee's forces were firmly entrenched around Cold Harbor, which ended up being one of the bloodiest battles of the war. Thousands of Federal troops died during the offensive, most on a single morning: June 3, 1864.

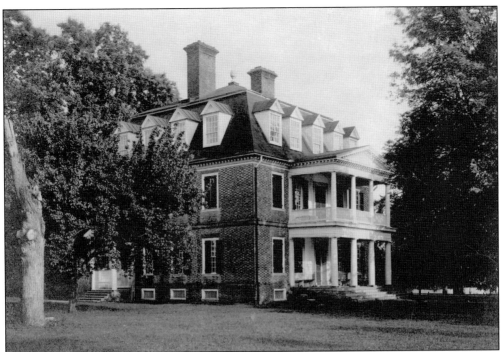

Shirley Plantation in Charles City County was first established by a land grant from the English crown in 1613 and has operated as a family-run plantation for 11 generations. Construction of the house seen here began about 1723 and was completed in 1738. Though open for public tours and educational programs, the house is still a family residence and a working plantation and is still owned by descendants of Edward Hill I, who started a farm on the property in 1638.

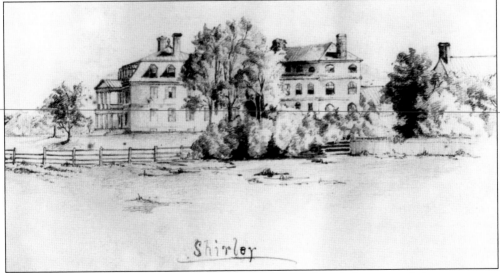

This sketch of the Shirley Plantation was drawn by an unidentified artist, and the provenance suggests the sketch was done sometime prior to the Civil War. The site included outbuildings such as a stable, a smokehouse, a corncrib, a dovecote, and a root cellar. Descendants of the original owner of Shirley Plantation intermarried with some of the wealthiest and most influential Virginians throughout the Colonial and Antebellum periods.

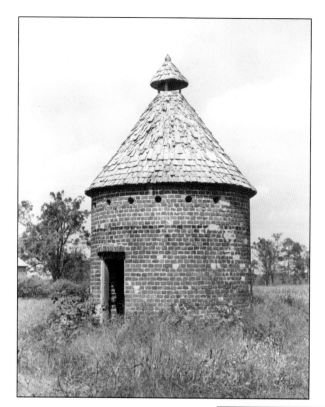

The brick dovecote at Shirley Plantation was photographed in 1959. In the 1700s, dovecotes provided the delicacy of squab, pigeons that had not fully matured their flying muscles and had very tender meat. A dovecote as grand as the one at Shirley Plantation would have been limited to the very wealthy, as any dovecote was a symbol of prosperity.

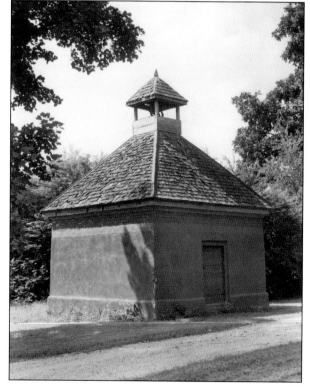

The smokehouse at Shirley Plantation is an unusually fine example of such a utilitarian building. Before refrigeration, salt-cured meat was smoked in a building, usually wooden, to preserve the meat and add flavor. Brick is an impractical material for a smokehouse because the salt deteriorates the brick, but a wooden shack would not have blended well on this grand estate.

St. Peter's Church in New Kent, Virginia, is an incredible historic treasure. Built between 1701 and 1703, the church is seen here in 1927. The parish historic record includes the marriage of Martha Custis (nee Dandridge) to her second husband, Col. George Washington, in 1759.

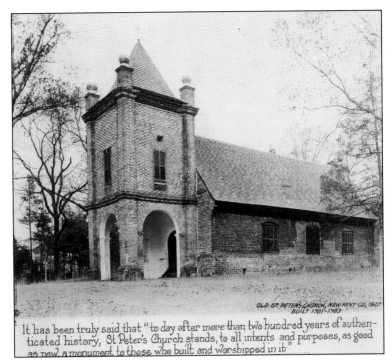

OLD ST. PETERS CHURCH, NEW KENT CO, 1927
BUILT 1701-1703

It has been truly said that "to day after more than two hundred years of authenticated history, St Peter's Church stands, to all intents and purposes, as good as new, a monument to those who built and worshipped in it"

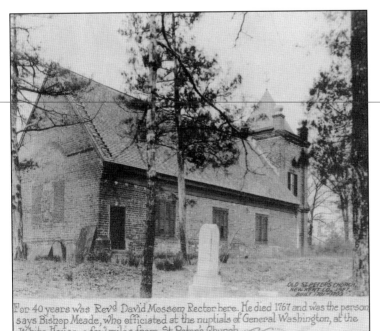

OLD ST PETERS CHURCH
NEW KENT CO, 1927
BUILT 1701-1703

For 40 years was Rev'd David Mossom Rector here. He died 1767 and was the person says Bishop Meade, who officiated at the nuptials of General Washington, at the White House, a few miles from St Peter's Church

This burial ground surrounds St. Peter's Church. Some of the tombstones are propped against the rear of the building. The parish register includes the family record of Martha Dandridge and her first husband, Daniel Parke Custis. Martha was widowed at the age of 25 and inherited a large fortune. At age 27, she married George Washington, whose personal wealth was vastly increased by the estate of his wife.

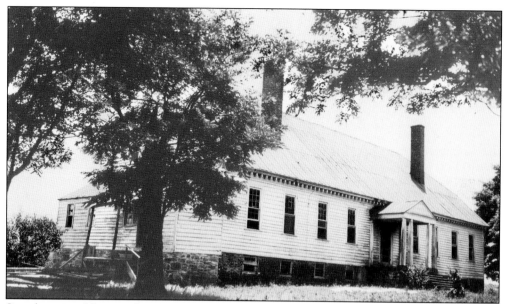

Scotchtown in Hanover County, Virginia, was the residence of Patrick Henry from 1771 to 1777. The house was built about 1720 by Charles Chiswell. The clipped point of the roof at either end of the house is called a Jerkin-head–style roof. Today, the property is owned and maintained by Preservation Virginia.

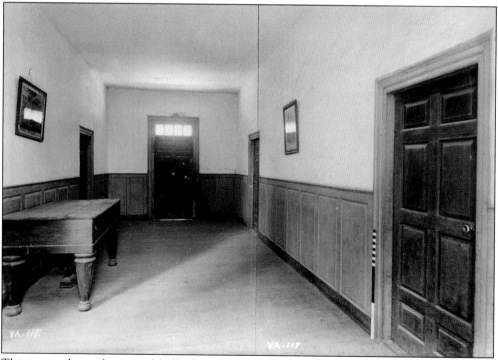

This image shows the central hall of Scotchtown. Patrick Henry's first wife, Sarah, started to show signs of mental illness around the time the family relocated to Scotchtown. Rather than confine her to an institution, Patrick Henry kept his wife in a basement room within Scotchtown. Sarah Henry died in 1775.

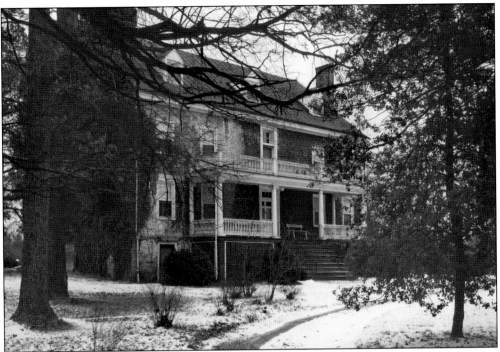

Walkerton Tavern, now managed as a museum by Henrico County, was built in 1824 by John Walker and served travelers along the stagecoach route north of Richmond. Located on Mountain Road in Glen Allen, the Walkerton Tavern building has served many community functions, including time as a store, a post office, a voting precinct, and a tavern.

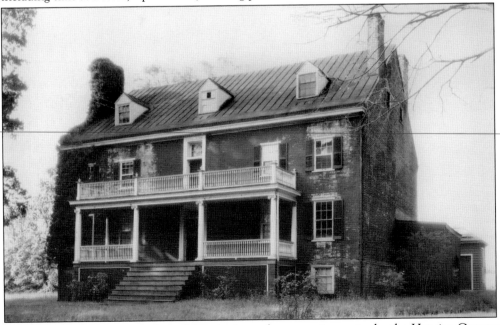

Today, Walkerton is operated as a historic site and community center by the Henrico County Recreation and Parks. The facility is used for historic and educational programs as well as community events and weddings. The tavern is adjacent to the Cultural Arts Center at Glen Allen.

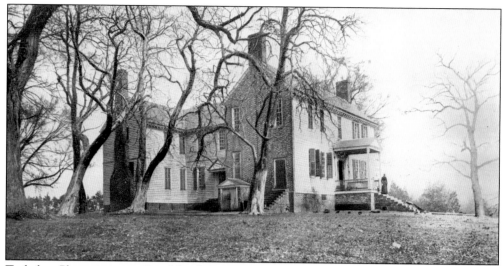

Tuckahoe Plantation is in Goochland County, Virginia, about 13 miles west of Richmond. The house was built in 1712 and was a childhood home of Thomas Jefferson's from age two to age nine, from 1745 until 1752. The house is in the shape of an H, a rare surviving example of a Colonial style, and was expanded to its current size between 1730 and 1745. This photograph was published in the *Burr McIntosh Monthly* in 1907.

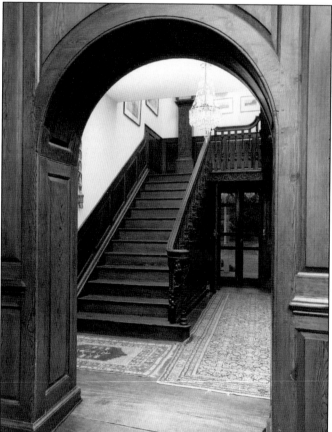

The millwork on the staircase at Tuckahoe is carved from black walnut. The North American tree was common in the area and was the wood of choice for furniture and fine millwork before mahogany became readily available in the 19th century. The wood is a dark color with intricate and beautiful veining.

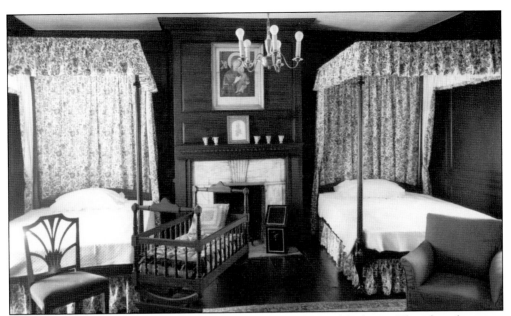

This bedroom at Tuckahoe Plantation is in the northwest corner of the house. Though in this image the space seems staged as in a historic house museum, Tuckahoe has always been privately owned. A preservation easement has been placed on the property to protect it from demolition or development, and the site is available for event rentals, but there are no public tours of the estate.

This large kitchen hearth demonstrates the scale of the enormous Tuckahoe Plantation house. In 18th-century Virginia on a plantation such as Tuckahoe, the kitchen was usually a separate outbuilding, keeping the main house free of the soot and spills associated with open-hearth cooking. The kitchen was also the domain of servants or slaves, whose work would be kept separate from the family within the house.

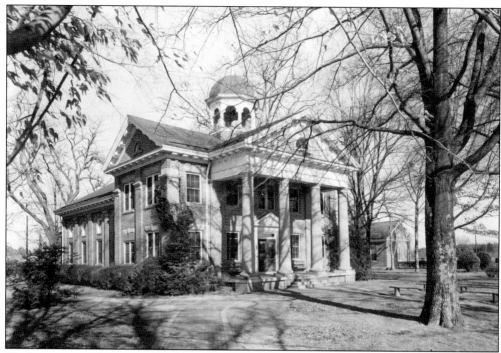

The historic courthouse complex at the Chesterfield County Courthouse features an 1892 jail, the Chesterfield County Museum, and the 1917 courthouse. The 1917 courthouse was built to replace the 1750 courthouse on the same site. Chesterfield County was once part of Henrico County but was carved out as a separate county in 1749. Henricus, the 1611 settlement established by the colonists from Jamestown, is now located within Chesterfield County. Henricus was financed by the Virginia Company of London and settlers sought a location that provided better protection and a healthier climate than the swampy area around Jamestown.

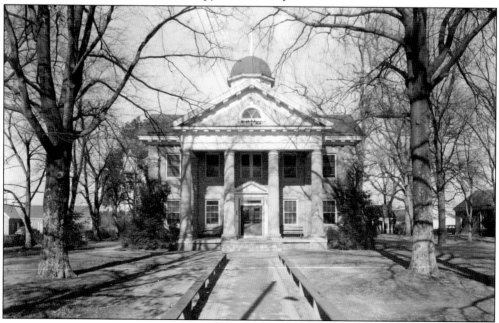

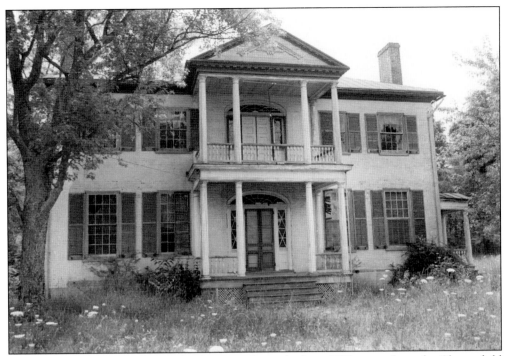

Magnolia Grange is a Federal-style plantation house built in 1822 across from the Chesterfield County Complex. The site once included a gristmill and tavern as well as several outbuildings.

Both images of Magnolia Grange on this page are from the Historic American Buildings Survey (HABS), a program administered by the National Park Service that is vital to the preservation and restoration of historic buildings. The survey process includes detailed architectural drawings (including measurements); interviews with owners, residents, and community members; photographs; and research into the history of the structure.

DISCOVER THOUSANDS OF LOCAL HISTORY BOOKS FEATURING MILLIONS OF VINTAGE IMAGES

Arcadia Publishing, the leading local history publisher in the United States, is committed to making history accessible and meaningful through publishing books that celebrate and preserve the heritage of America's people and places.

Find more books like this at
www.arcadiapublishing.com

Search for your hometown history, your old stomping grounds, and even your favorite sports team.